Living in a Nutshell

Posh and Portable Decorating Ideas for Small Spaces

Janet Lee

Photography by Aimée Herring

HARPER
DESIGN

An Imprint of HarperCollinsPublishers

Living in Nutshell
Posh and Portable Decorating Ideas for Small Spaces

HarperCollins books may be purchased for educational, business, or sales promotional use. For information please write: Special Markets Department, HarperCollins*Publishers*, 10 East 53rd Street, New York, NY 10022.

First published in 2012 by
Harper Design
An Imprint of HarperCollins*Publishers*
10 East 53rd Street
New York, NY 10022
Tel: (212) 207-7000
Fax: (212) 207-7654
harperdesign@harpercollins.com
www.harpercollins.com

Distributed throughout the world by
HarperCollins*Publishers*
10 East 53rd Street
New York, NY 10022
Fax: (212) 207-7654

Library of Congress Control Number: 2011927594

ISBN 978-0-06-206069-3

Book design by Niloo Tehranchi
Printed in China
First Printing, 2012

To my inimitable style muse, my mother, Jin Hwa,
whose warmth and strength define true elegance,
and to my dear father, Sun, who lives up to
his name with a pioneering spirit that shines.

[CONTENTS]

APPENDICES

Introduction

By my last count, I've lived in twelve pocket-sized apartments over the past twenty years—and not one of those personal spaces has measured more than 750 square feet. It's hard to forget the studio apartment where I could reach the refrigerator while sitting on my living room sofa, or the city rental where my guests would, more often than not, mistakenly toss their coats into the "closet"—which was actually my bedroom!

I guess you could say that I'm a serial small space nester with a unique vantage point. Each apartment I've lived in—with its laundry list of lighting and structural flaws—has become a personal decorating lab where I've created and road-tested my ideas. Early on, I underestimated the importance of using wall anchors when hanging heavy objects—because I didn't use them, all my curtain rods fell down, along with chunks of drywall. Now, tension rods are my small space staple. That disaster motivated me to find solutions that are affordable, that I could do myself, and that wouldn't damage walls or windows permanently. Just as important to me is portability: I want to take the décor with me when I move. Happily, these concepts have allowed me to live a little larger and more luxuriously within tight quarters, for with every mistake I made, there also came a breakthrough.

In a nutshell, my mantra for small space design is to delight, dazzle, and divert. First, delight your guests with design details so thoughtful, original, even outrageous, they'll hardly notice you live in a box. Next, dazzle them with flattering lighting, luxurious fabrics, and accessories that give off a bit of sparkle. Finally, divert any negative attention from the flaws of your space with whimsical decorative finishes.

These are the small space decorating principles that guide the projects you'll find here. If you follow them, you'll be able to impart a feeling of grandeur and glamour to any space regardless of its square footage. Even if you only have an hour, the simplest change can make a big style impact. The projects are ranked as "quickies" (1 hour or less), "one-nighters" (2 to 5 hours), or "weekenders" (6-plus hours) to help you gauge the time commitment involved.

My hope is that this book motivates you to adopt a less size-ist, less traditional attitude toward small space design: in other words, focus on what you can do, not what you can't. By experimenting with bold paint colors, unconventional materials and fabric, unexpected lighting, and innovative storage ideas, your space, no matter how vertically and horizontally challenged it is, will begin to reflect your personality and style. Venturing into new decorating territory can be daunting, but you're not alone. Just think of me as your design buddy—the one who's happily made all the mistakes and done all of the footwork for you.

In a nutshell, my mantra for small space design is to delight, dazzle, and divert.

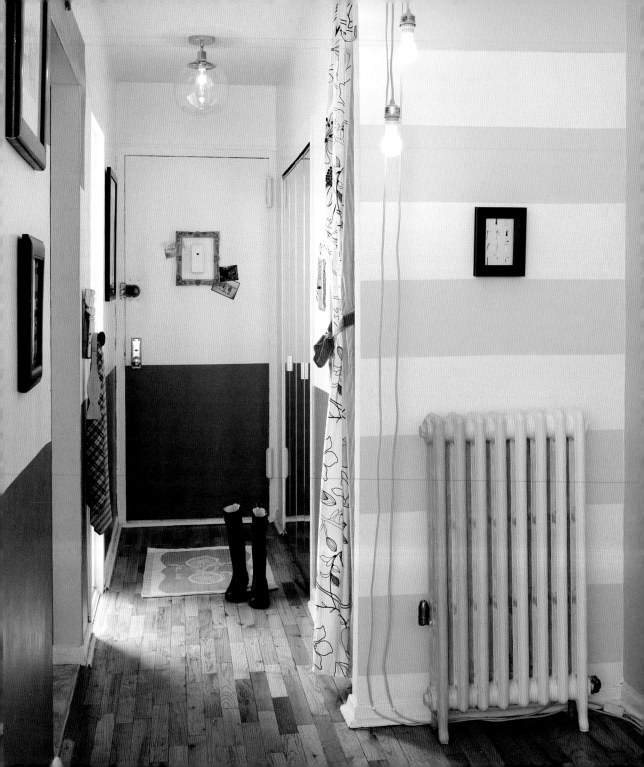

Flaunt Your Flaws

"The room is so small, the mice are hunchbacked."
—Henny Youngman, from *Take My Life, Please!*, 1992

Not able to leap tall buildings in a single bound? Short of acquiring superhero powers, transforming cramped quarters into a spacious and luxurious retreat is no easy feat. Throw in bad views, low lighting, and a popcorn stucco ceiling, and you have to ward off a trifecta of decorating villains.

How do you get back the power? By flaunting those flaws in unpredictable ways and reinventing eyesores into one-of-a-kind design attractions. It's the imperfections that will give your home a depth of personality and loads of character.

This chapter features bona fide living, breathing spaces that are short on square footage and long on their lists of inherited flaws. But once the decorating dust settled, through trial and error, the most clever and chic design remedies remained standing. They prove that sometimes in small spaces, you have to adopt a whole new design mantra. Flaunt it. Don't hide it.

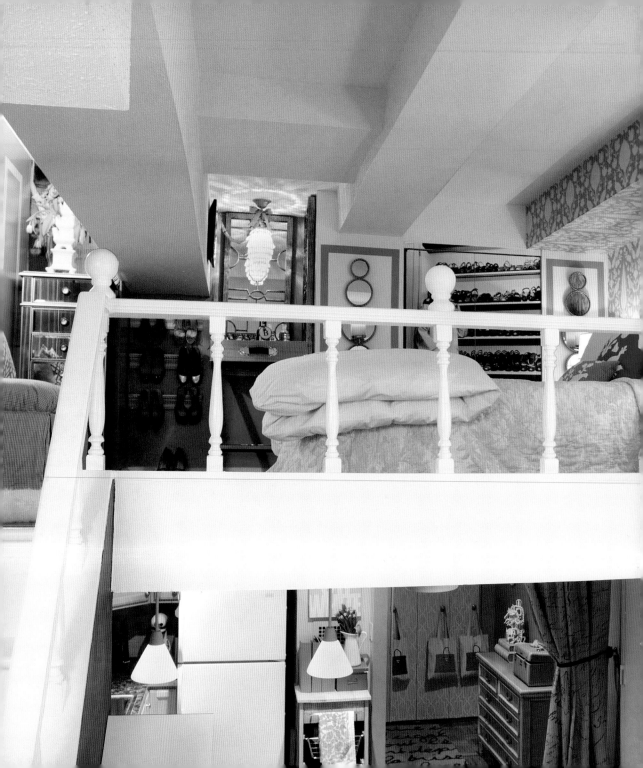

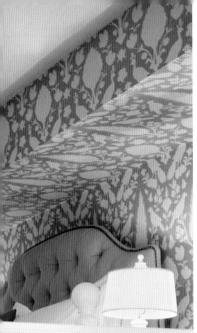

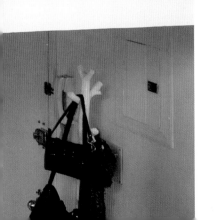

Divide and Conquer Your Digs

It took some clever counterintuitive thinking to boost the style of this tiny 12-by-11-foot sleeping loft (with a 4-foot-tall ceiling) from claustrophobic to cozy. Dividing the loft into lots of little "rooms" or "zones" actually magnifies the feeling of expansiveness and dimension instead of shrinking the space. A reading nook, dressing area, bar lounge, and sleeping alcove make this nest look like a grand salon.

BEFORE

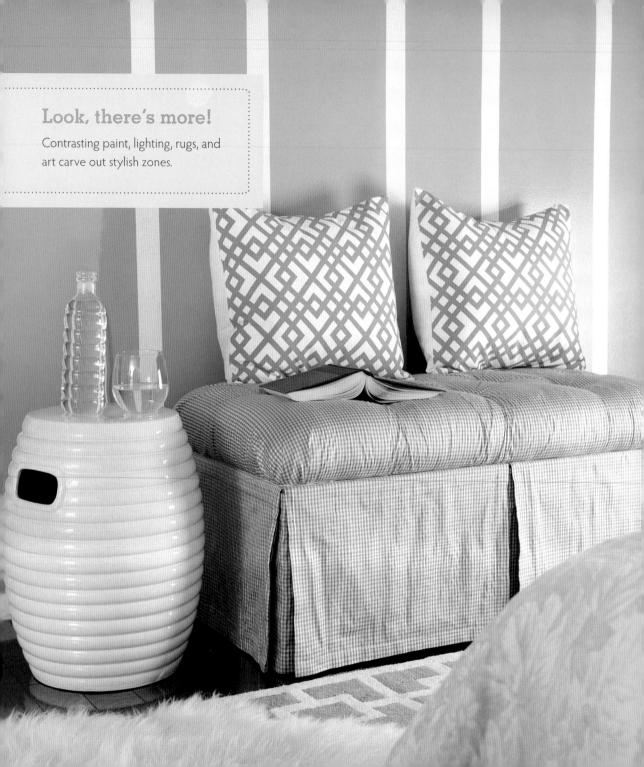

Look, there's more!
Contrasting paint, lighting, rugs, and art carve out stylish zones.

Bert the Turtle to the Rescue!

RANKING: QUICKIE ⊘⊘⊘

Watch your head! Measuring just 3 feet high, the entrance into this sleeping loft is potentially perilous with rows of low-hanging beams covered in stucco. Taking a cue from the Cold War era (extreme moments call for extreme measures), I downloaded and laminated a 1950s copy of Bert the Turtle, warning American children to "duck and cover" in case of an atomic attack. Now, thanks to Bert, a structural flaw is a cheeky design highlight.

BEFORE

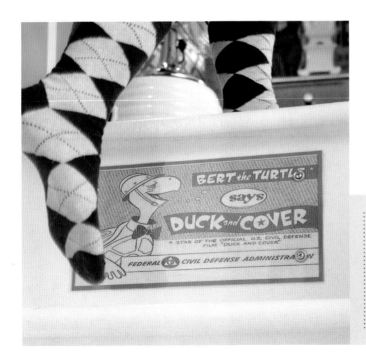

Look, there's more!

Large-head screws and metal washers give this retro sign an industrial look.

Wallpaper Canopy

Stuck for ways to camouflage ugly beams? If you can't beat 'em, wallpaper 'em. Accentuate a not-so-positive ceiling beam with sophisticated wallpaper that dazzles. In this bedroom, stucco was stripped from one of the beams and patterned wallpaper extended up and over it. Now, the beam provides a chic canopy effect over the new bed and visually raises the eyeline of the ceiling. The canopy deflects attention from the remaining stucco-covered beams and turns a problem area into a knockout feature in the room!

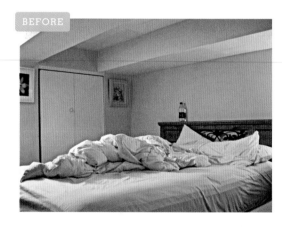

BEFORE

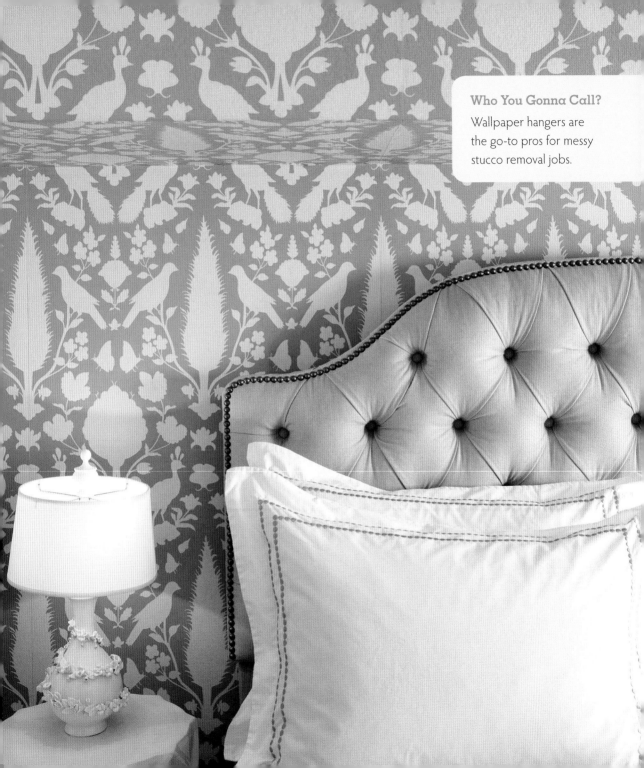

Who You Gonna Call?
Wallpaper hangers are the go-to pros for messy stucco removal jobs.

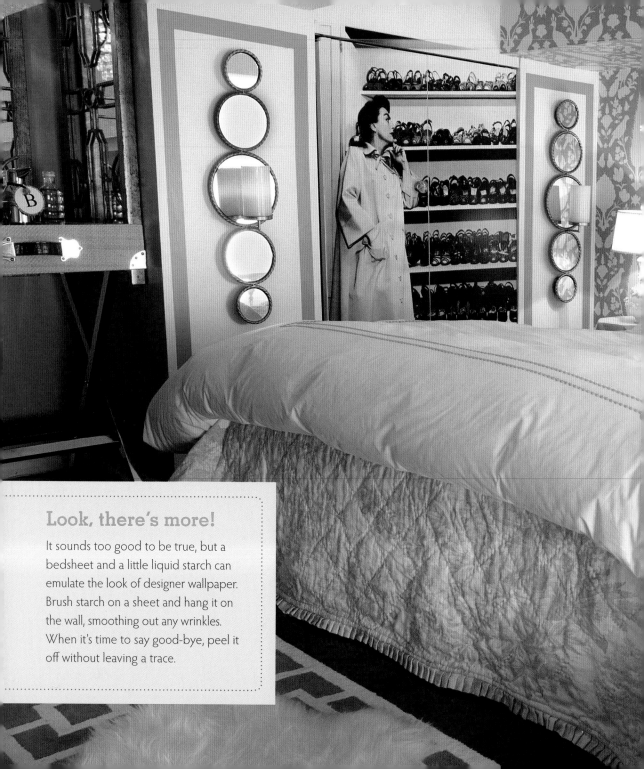

Look, there's more!

It sounds too good to be true, but a bedsheet and a little liquid starch can emulate the look of designer wallpaper. Brush starch on a sheet and hang it on the wall, smoothing out any wrinkles. When it's time to say good-bye, peel it off without leaving a trace.

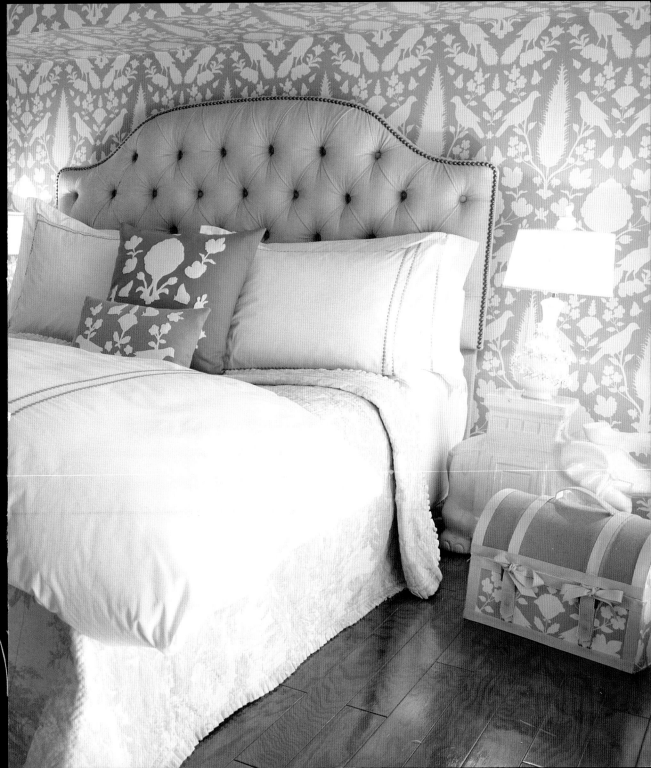

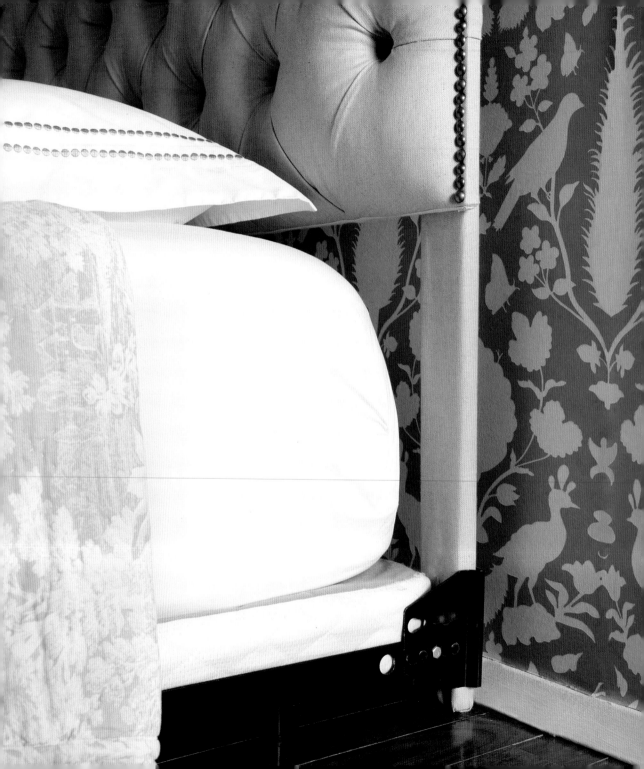

Bedroom Standards and Practices

RANKING: ONE-NIGHTER ☺ ☺ ☺

In a low-ceilinged sleeping loft, the knee-jerk reaction is to set the mattress on the floor. In a desperate bid for even more space, the legs of a headboard were cut down to fit. But scaling down the furniture actually dwarfed this small space and made it look and feel like a college dorm. The trick is to do the opposite. If your bedroom is on the petite side, go ahead and furnish it from the regular adult-sized section. Raising the mattress onto a low-profile metal bed frame (about 3 ½ inches off the floor) made this bed tall enough to attach a standard-height queen-sized headboard. Now, this sleeping loft looks lavish and spacious.

BEFORE

In a Nutshell

Dividing your diminutive domain into distinct, stylish zones lets it function in a larger, more luxurious way. Highlighting neglected niches with wallpaper, paint, and accessories in different colors makes every square inch count.

Dressing Up a Forgotten Zone

RANKING: WEEKENDER ⊙ ⊙ ⊙

For years, this plain-Jane, pass-through hallway was passed over! But simply hanging a linen curtain near the front door of the apartment immediately redefined it as a French-inspired dressing room. An oversized Parisian mansard mirror gives the space a sense of history, and a wool runner with French script immediately draws you in. Here is a sophisticated boudoir you want to spend some time in.

BEFORE

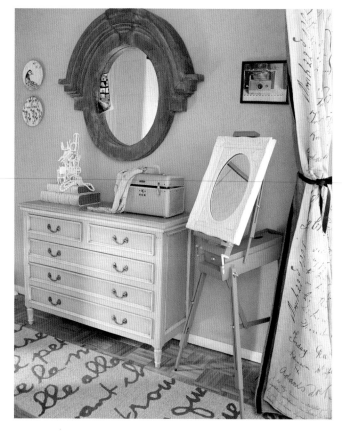

Look, there's more!

Modern metallic wallpaper on generic closet doors anchors this zone, adding shine and visually expanding a formerly dark space.

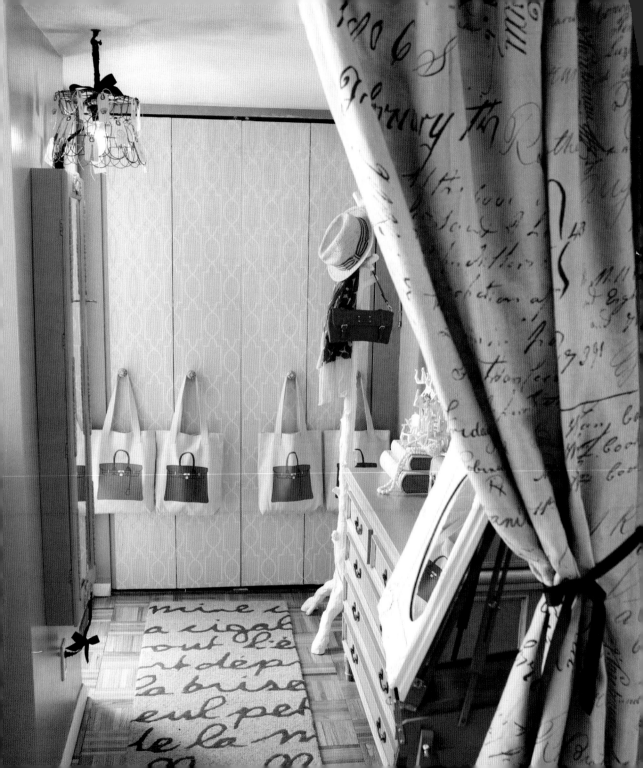

Grand Entrance

RANKING: WEEKENDER ⊘ ⊘ ⊘

Why let modest doorways blend in when you can make them command attention? Bold green paint and molding appliqués draw the eye into this 15-square-foot kitchenette. The wide painted border, designed simply by measuring and taping off a 2-foot section from the top of the doorway, stands in for much pricier crown molding.

In a Nutshell

Adopt a whole new way of seeing entryways. Whether the access point you want to emphasize frames a hallway, a kitchen entry, or even a set of closet doors, seize the opportunity to inject grandeur and drama. Getting there is half the fun!

Look, there's more!

Repositionable adhesive strips keep molding appliqués portable. When painting molding, finishing with two layers of high-gloss clear acrylic paint adds sheen and style presence.

Raising the Bar

The curtain was about to close on this dark, forgotten bedroom corner
(a minuscule 26 inches wide) until the secret glamour of the space was
unleashed with a Hollywood Regency–inspired bar! Accessorized with a
few mirrors and new lighting, this little niche now lives luxe and large.

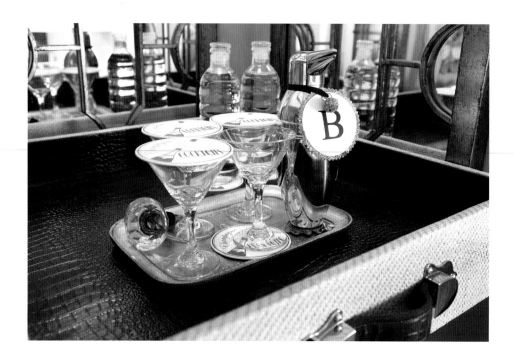

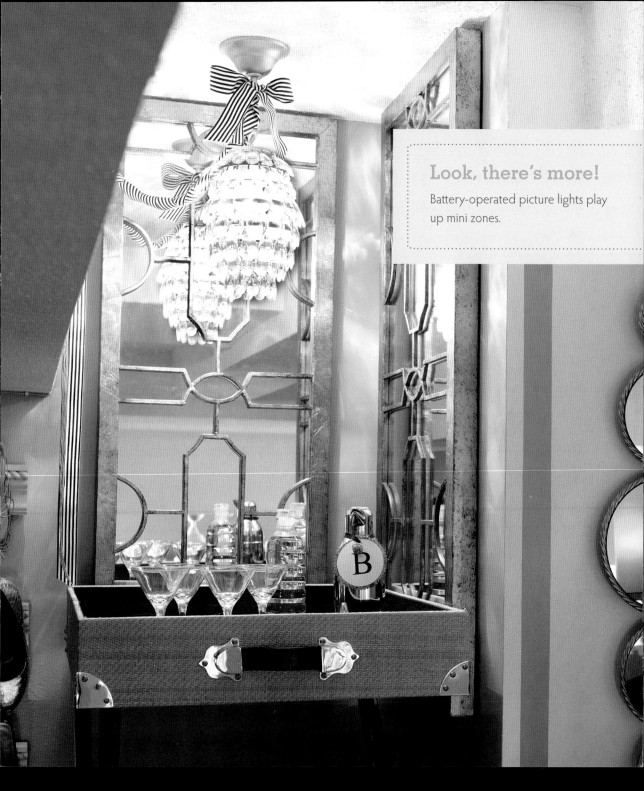

Look, there's more!

Battery-operated picture lights play up mini zones.

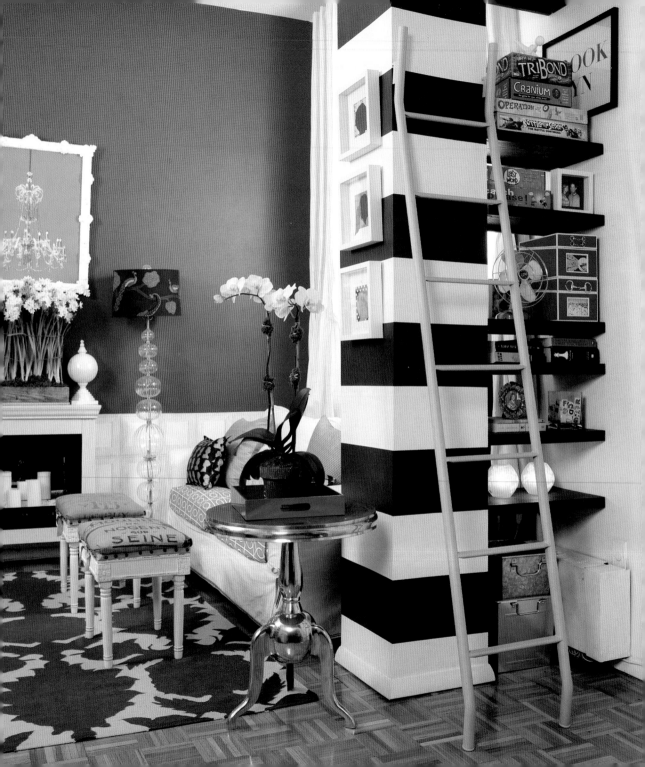

Climbing Up the Style Ladder

RANKING: QUICKIE ⊙ ⊙ ⊙

Don't pigeonhole your itty-bitty digs. Make a grand gesture toward the petite stature of your place by adding a tall library ladder. It draws the eye upward and elongates a small space in a surprising way. Place a ladder next to a fireplace, in the kitchen—even in the bathroom.

BEFORE

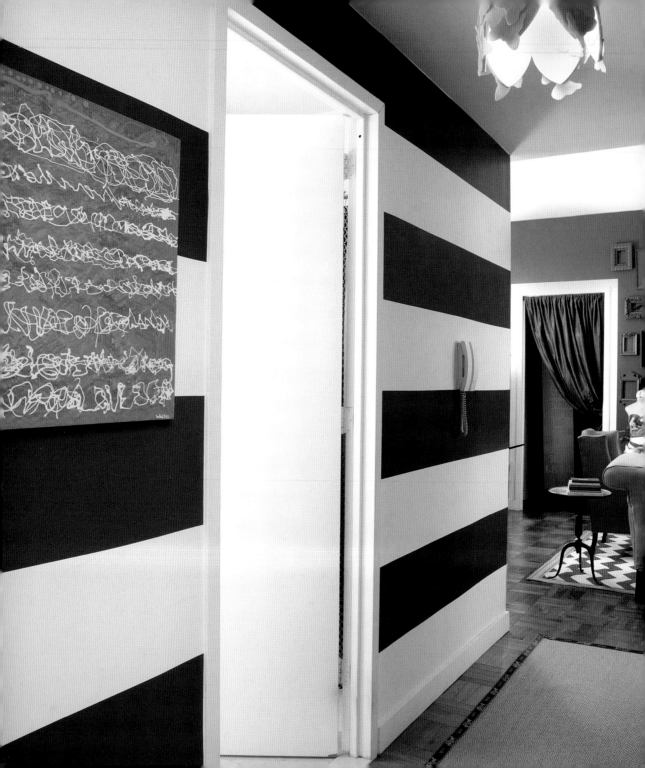

The Power of Perfect Stripes

RANKING: WEEKENDER ⊘ ⊘ ⊘

It's one of fashion's ten commandments for the petite: "Thou shall not wear horizontal stripes." But you can break the rules when it comes to dressing your short digs. Wide horizontal stripes are a winning modern contrast to the small scale of a space. From floor to ceiling, they fool the eye into believing a room is broader and more generous than its actual square footage. Think of a wide stripe as a true-blue stand-in for decorative moldings that give a room architectural oomph. Pound for pound, skinny stripes don't have the same design heft and from afar can appear more as a textured surface than a design detail.

How Did You Do That?

1. Paint the lighter color onto the wall as a base coat. Let dry completely.
2. Apply painter's tape to the wall to mark off horizontal stripes (to be painted a darker color).
3. Lightly brush the lighter base color along the inside seams of tape. Let dry 20 to 25 minutes. The base color will fill the voids left under the tape so any seepage will just blend into the background.
4. Paint the darker contrast color over the entire area bordered by the tape. Pull off the tape as soon as the paint is fully dry.

In a Nutshell

Talk about maximizing every square inch of a space—in a mere 26 inches, you've got an elegant cool bar; 16 3/8 inches yields an instant library, along with a ladder that scales the room's height; with 15 inches to spare, you've got the makings of a vertical gallery with stripes. Any small, overlooked spot in your space can become a destination that exudes purpose and style.

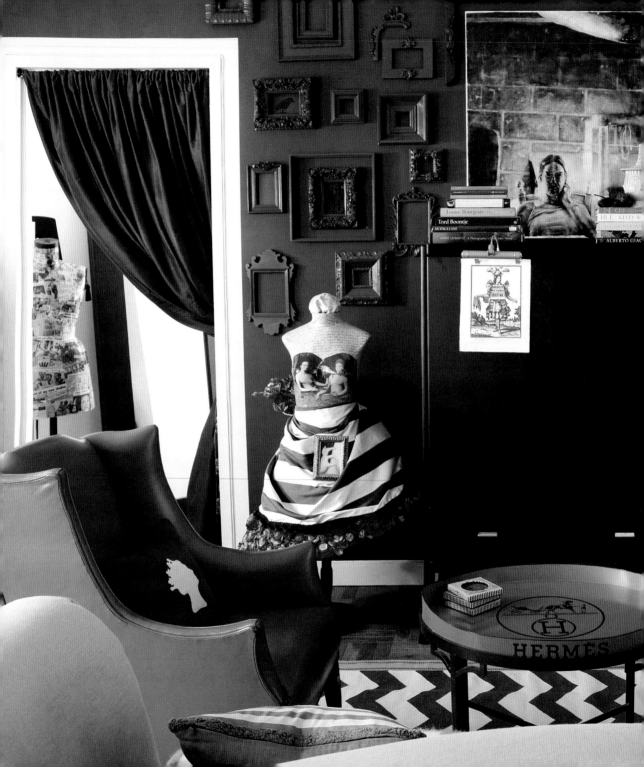

Gray Is the New Black

RANKING: WEEKENDER ☺ ☺ ☺

Wearing black is slimming, but what do dark colors do to an already tiny space? Cool tones on the color wheel like blues, violets, certain grays, and brown are referred to as "receding" because when painted in a space they cast the perfect illusion that the walls go back further than they really do. Much the way a dark sky at midnight appears to be infinite, cramped walls appear to recede, creating a perception of depth and adding drama to a room. No fear of dark colors shrinking your skinny space anymore.

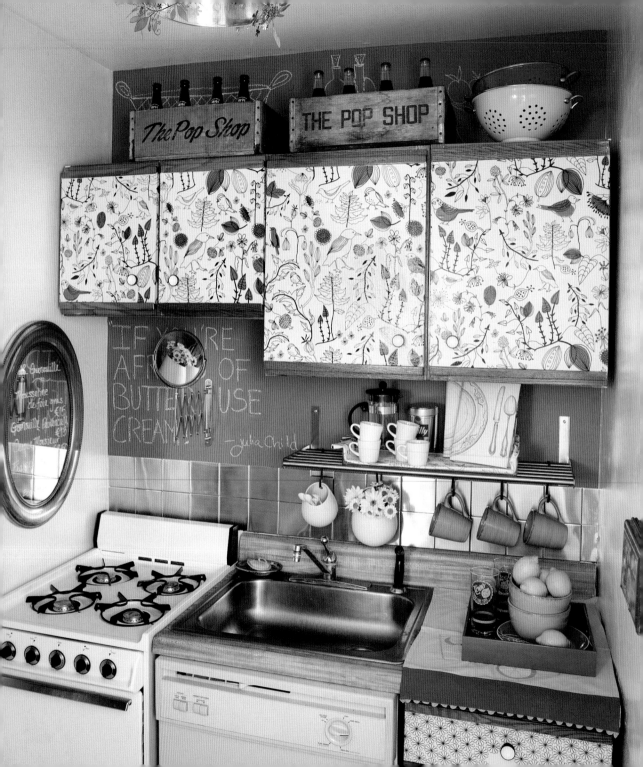

The Pop Shop

THE POP SHOP

IF YOU'RE
AFRAID OF
BUTTER USE
CREAM!
—Julia Child

Look, there's more!

Paint strip cards usually have two very light shades (for trim or ceiling), two medium (for walls), and two dark (for trim or ceiling). When in doubt about wall color, go for the darker option—it will always look lighter on the wall.

Painting color samples on white foam core boards is a foolproof way to test-drive paint choices in your room. Brush two coats of paint on an 8-by-10-inch board and let it dry for 2 hours for a true representation of the color. Hang up several boards in your room with painter's tape, which won't damage walls, and see how the colors look morning, day, and night. You can move sample boards all around the room, which is easier than painting colors directly on the wall. Take boards with you when you're shopping for matching curtains and bedding. They're small enough to fit in your tote bag.

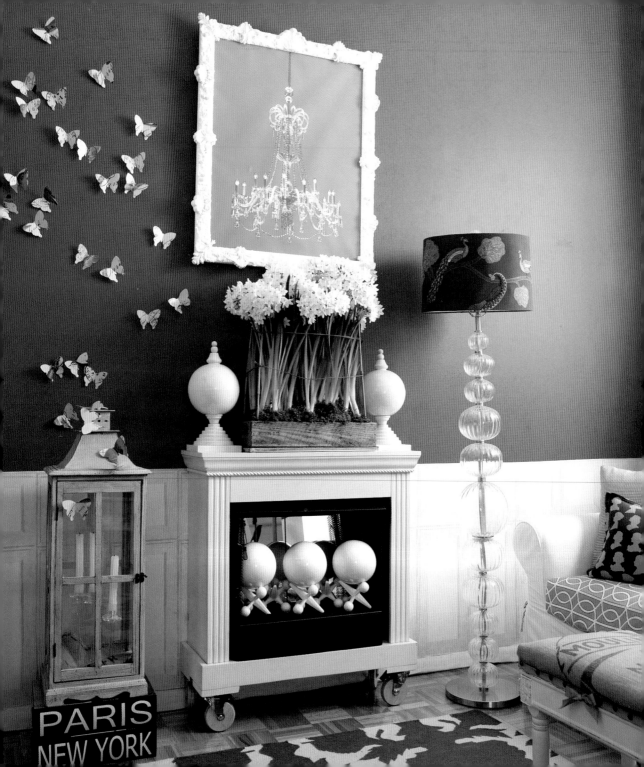

PARIS
NEW YORK

Go Big or Go Home

RANKING: QUICKIE ⊘ ⊘ ⊘

In a petite pod, sometimes it's better to play against type and decorate with a few oversized statement pieces. A cluster of small mirrors, a skimpy coffee table, and a junior-sized sofa will only break up the eyeline of a room, making it look and feel stunted. Going big with one or two key items anchors a small room, gives it a feeling of importance, and tricks the eye into seeing it as a much larger, more expansive space. Proving the point here, a vertical grouping of oversized finials, a tall glass floor lamp, and a large piece of art carry the eye upward, blurring the boundaries of a space-challenged living room.

BEFORE

In a Nutshell

Sometimes you have to challenge decorating logic to maximize the perception of size in the smallest of spaces. Choosing a few oversized pieces of furniture and accessories instead of lots of smaller items will anchor a room and heighten the illusion of space and grandeur. Mixing in deep, rich paint colors will visually recede boundaries marked by cramped walls and ceilings.

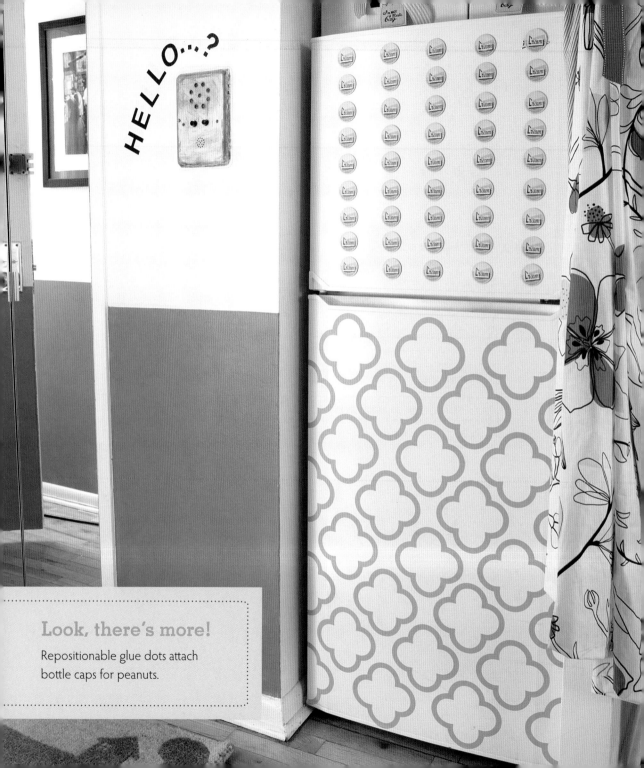

HELLO...?

Look, there's more!
Repositionable glue dots attach bottle caps for peanuts.

Fridge Fit for a Foyer

RANKING: QUICKIE ⊘⊘⊘

There's no ignoring the elephant in this rental studio apartment. The refrigerator stands unabashedly—in the entry hallway! Thanks to a simple collage of vintage milk bottle caps and removable yellow clover decals, this fridge says, "Hey, look at me!" It's now one of the apartment's quirky attractions.

Look, there's more!

A bold curtain swag lets you play hide-and-seek with the fridge, depending on your mood.

BEFORE

Radiator Blues and Yellows and Pinks, Oh My!

Need a cure for a case of the radiator blues? With a pop of paint, an old cast-iron radiator will no longer be an eyesore that leaves you cold. Spice it up with a bold gradated ombré pattern. Or highlight the radiator with one hot color that contrasts to your wall. Oil-based paint will withstand the heat the best. If you're renting, get approval from your landlord first.

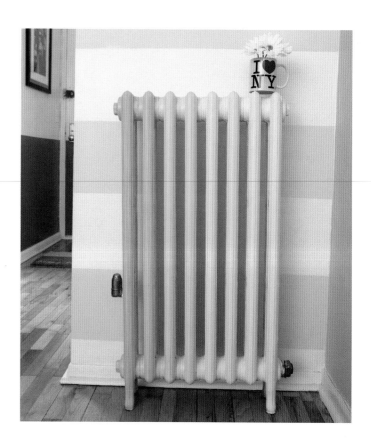

How Did You Do That?

1. Clean the radiator with soap and water.
2. Use an organic paint stripper to remove old paint bits.
3. Paint two coats of oil-based primer. Let dry after each coat.
4. For an ombré design, choose four or five gradated shades of oil paint (picking the companion shades on a paint chip card is a surefire tip). Paint each radiator section a different shade. You probably will need two coats for each color. Let dry.
5. Run the radiator with the windows open to get rid of the fumes.

◇◇◇

A Room with No View

RANKING: QUICKIE ⊘ ⊘ ⊘

If all you see from your window is a brick wall, don't bother blocking it—frame it! Make the brick wall across the way center stage by hanging an empty ornate picture frame right down the middle of the window. A silk ribbon hangs the frame with a dash of style. Battery-operated mini spotlights play up your million-dollar view. Find affordable spots at party supply stores.

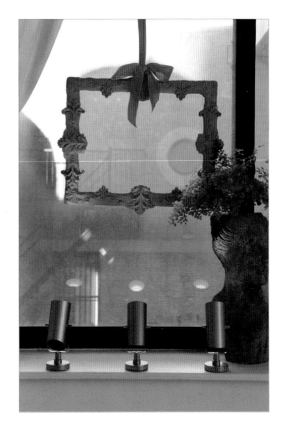

Cat Scratch Fever

RANKING: ONE-NIGHTER ⊘ ⊘ ⊘

Four-legged friends make the tiniest nutshell feel like home, but where do you hide a hideous cat scratching post? This plastic doggie night-light, wrapped in jute twine with a little glue, does double duty as modern sculpture. Don't forget the cardboard bone!

In a Nutshell

Don't let nonnegotiable, unmovable flaws and eyesores push you to the wall. Make a preemptive design strike and use a sense of humor and the element of surprise as your secret weapons to celebrate the not-so-perfect features in your home.

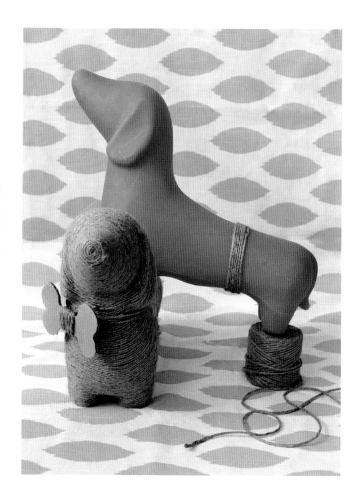

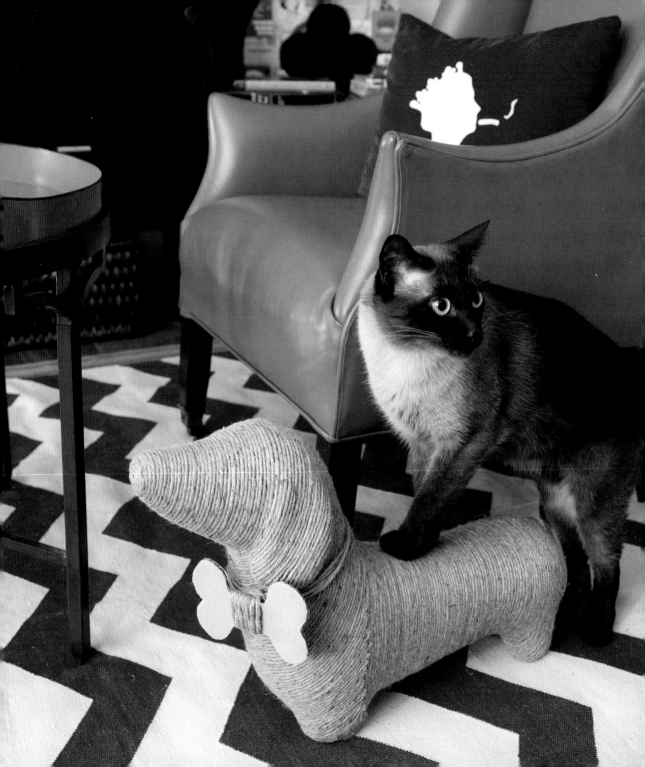

Lifting the Curtain on a Skimpy Space

RANKING: QUICKIE ⊘ ⊘ ⊘

If people mistake your bedroom for the coat closet, stand proud and adopt an open-door policy instead. Ask your landlord to remove and store the door (you'll increase your livable real estate by 6 to 7 feet). Hang a silk drape double the width of the door for a glam entrance no one will ever confuse for the closet again.

Look, there's more!

A curtain tension rod means no-drill installation.

In a Nutshell

You can instantly open up a floor plan by removing doors between living areas. This will increase the spatial flow of a small area, and in this case, make a bedroom feel like a boudoir rather than a box.

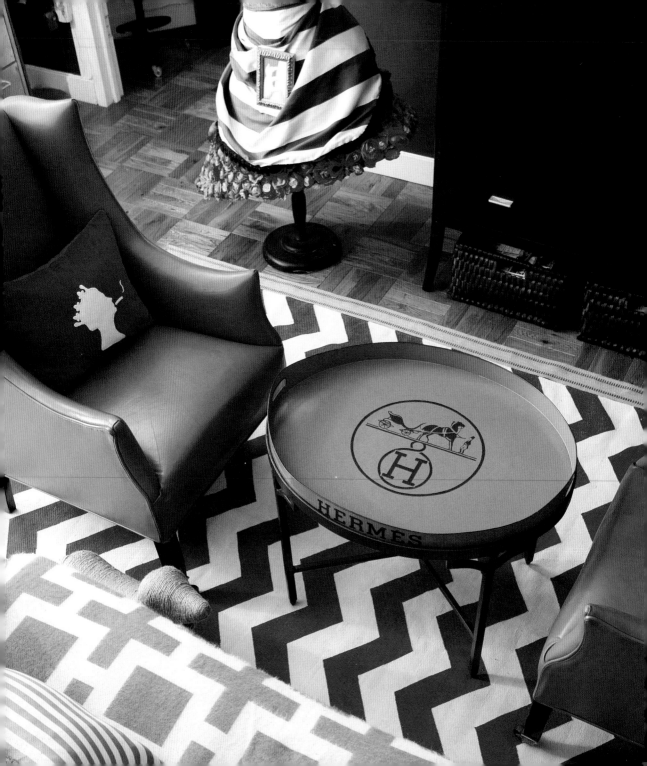

Couture Décor

"If I could find a real-life place that made me feel like Tiffany's, then I'd buy furniture and give the cat a name."

—Holly Golightly, from *Breakfast at Tiffany's* by Truman Capote, 1958

You might not live in designer digs, but a little touch of couture, sprinkled with a sense of humor and kitsch, can go a long way in elevating a humble habitat to runway-worthy status. With a wink and a nod to the designer original (I take only my shoe and handbag labels seriously), these DIY couture projects will delight any die-hard "labels" girl out there looking for a little luxe style on a budget.

And beyond designer labels, love is in the couture details, so mix in layers of sumptuous fabrics like silk and cashmere, highlight handmade finishes, and feature accessories that shimmer and shine. These grand touches have a magical way of dazzling and drawing attention away from your space's shortcomings.

Don't forget, just like your favorite designer shoe collection, this is couture décor you can always take with you.

First-Class Stamped Ribbon

RANKING: ONE-NIGHTER ⊘ ⊘ ⊘

Pay homage to the House of Hermès with this rubber-stamped ribbon. Use white fabric paint and two rubber stamps: one with a horse and buggy and one that says "Paris." Print on brown grosgrain ribbon (the kind with white stitch marks). Wrap the ribbons around an urn or use as swanky curtain tiebacks.

Look, there's more!

Heat-setting makes fabric paint permanent! Use an iron and follow the manufacturer's instructions.

Designer-Brand Border Rug

RANKING: ONE-NIGHTER ⊘ ⊘ ⊘

Show true brand loyalty by embellishing a plain sisal rug with the Hermès-inspired stamped ribbon. To make things easy, use a rug with a presewn fabric border as your base. Attach the printed ribbon with fabric glue and fold under or cut the corners diagonally for a mitered look.

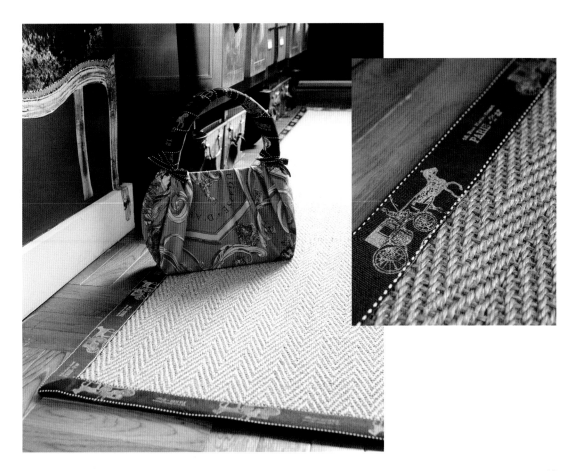

Birkin Bag or Bust

RANKING: QUICKIE ☻☻☻

Tired of being on the waiting list lusting for the latest Birkin bag? Dream no more with these adorable and affordable "I Heart Birkin" cotton tote bags. Hang three or four of your favorite colors in a row on crystal knobs mounted on a bedroom wall or closet doors. They're a brilliant storage fix for go-to essentials like scarves, stockings, and hair accessories. Velcro dots function as invisible closures to keep everything tucked in and tidy.

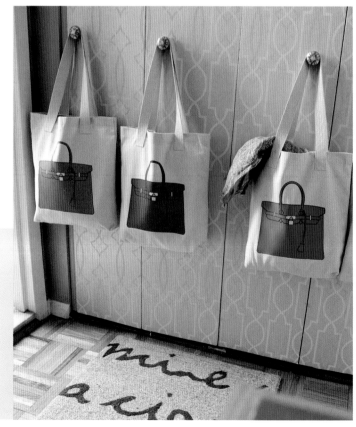

In a Nutshell

Let couture décor work *for* you! You'll not only fulfill your designer label envy but create chic storage solutions at the same time—and let everyone in on the joke.

Haute Handle Hardware

If you're a Gucci girl, add Gucci-inspired horse bit hardware to a plain photo file box or jewelry chest. For very little money, you can buy authentic mini horse bits that are the perfect size for a drawer handle. Double-pointed tacks secure the bits and are practically invisible.

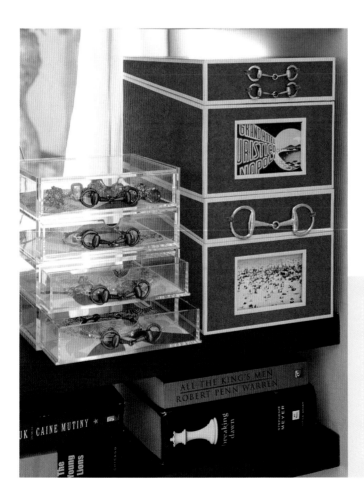

In a Nutshell

Couture décor not only gives your space playful upscale status but becomes your multitasking brand on things you use every day, from filing to floors.

Honey, I Shrunk (Wrapped) the File Cabinet!

RANKING: ONE-NIGHTER ⊘ ⊘ ⊘

File this idea under "F" for fab-u-lous! It was inspired by a New York City subway shrink-wrapped in a jumbo movie ad that hugged every curve of the train. I used the same removable vinyl adhesive to shrink-wrap an old file cabinet. With a wink to my favorite "Louis" couture, my initials "JL" playfully stand in for the iconic "LV." Fashion is fickle—so peel it right off when you get bored.

In a Nutshell

Industrial and commercial vendors, like a bus wrap ad company or printers that produce vinyl banners, are valuable untapped design resources that allow you to customize any utilitarian object in your home with a one-of-a kind couture look for less. Check for them online.

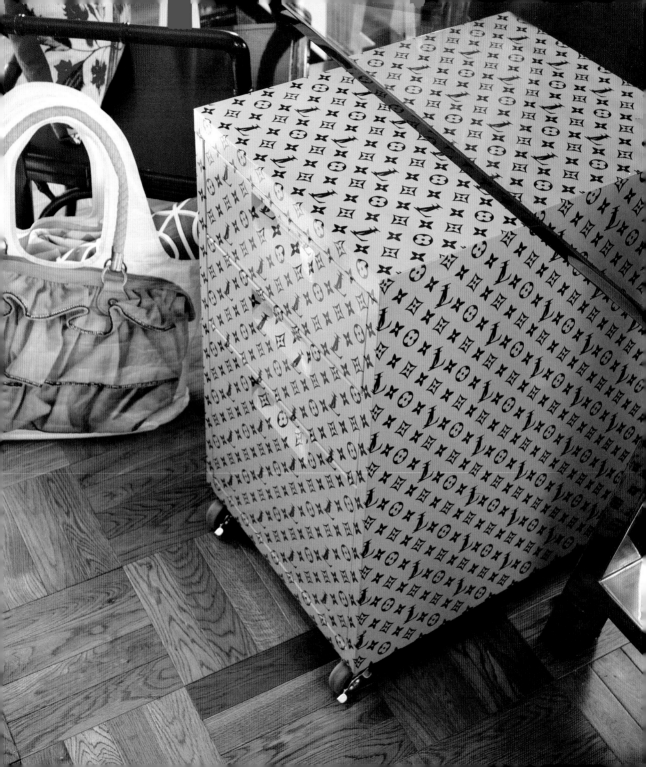

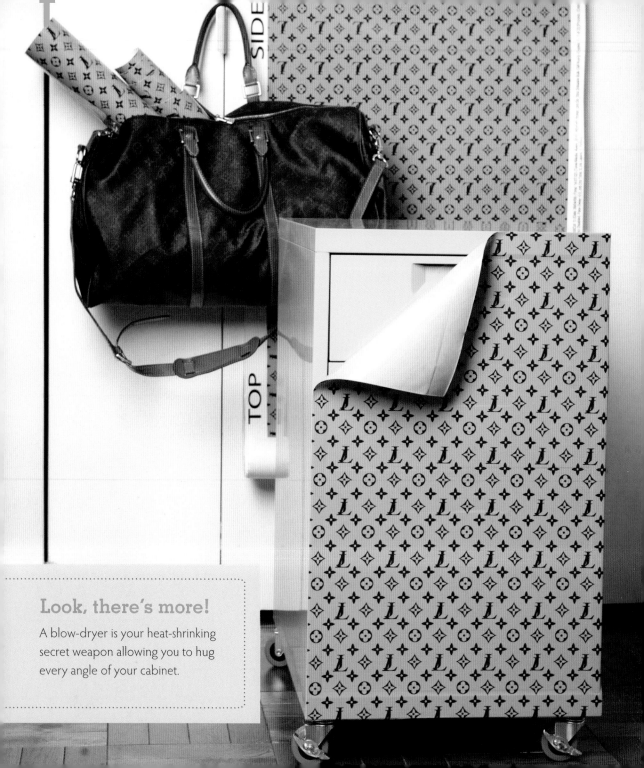

Look, there's more!

A blow-dryer is your heat-shrinking secret weapon allowing you to hug every angle of your cabinet.

How Did You Do That?

1. Send artwork and file cabinet measurements to a bus wrap ad company near you. For an extra fee, they often can help with graphic design.
2. You'll receive printed vinyl sheets. For this project, there were five sheets sized to fit the top, front, back, and two sides of the cabinet (no need to cover the bottom).
3. Cover the front of the cabinet first, smoothing the vinyl with your hand (or an old credit card) as you peel off the backing.
4. Use a sharp craft knife to cut into the front of the cabinet, outlining all its drawers.
5. Matching the design on the front, place vinyl on remaining sides. Gently press and smooth the vinyl to the drawer handles, using the heat of a blow-dryer to help you mold it. Vinyl will stretch, so be careful.

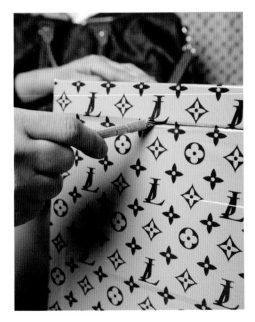

STEP 4

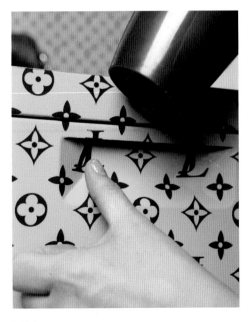

STEP 5

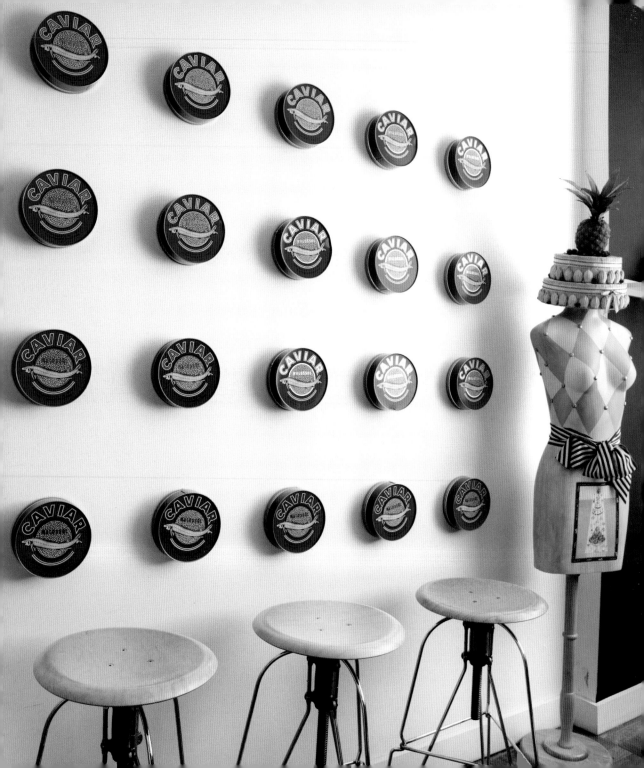

Caviar Tin Pop Art

RANKING: ONE-NIGHTER ⊘ ⊘ ⊘

Add a little "pop couture" à la Andy Warhol to your kitchen with the ultimate luxe designer food label. Beluga caviar, anyone? Brand new empty caviar tins hung in groups of six or more are a bold modern pop art exhibit in your kitchen; the power of multiples maximizes their impact. Caviar tin paper templates taped to the wall allow you to chalk off and preview the design before committing to it. Hang the tins with removable adhesive wall strips so you can wrap them up "to go" when you move on to your next space.

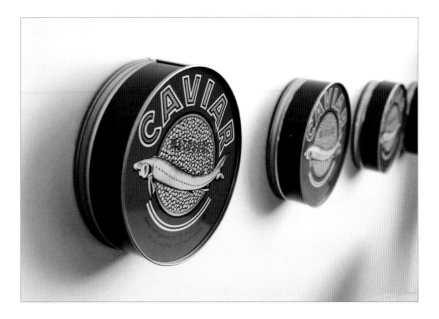

Couture Tattoo Art

RANKING: ONE-NIGHTER ⊙ ⊙ ⊙

Body tattoos as room décor? It's chic if it's Chanel! Turn Coco-inspired temporary body tattoos (or any temporary body art) into a personal piece of art. Rub the tattoos on your shoulder, wrist, or ankle and then take some arty black-and-white snaps. Use free software to format your photos into an old-fashioned photo booth strip look. Frame them or tuck photo strips into a mirror. They're for your eyes only!

Look, there's more!

Print original images onto inexpensive tattoo paper so you'll always have a spare.

In a Nutshell

The ultimate couture muse is *you*! Creating your own designer self-portrait is personally chic.

Posh Pillow Appliqués

RANKING: WEEKENDER ⊘ ⊘ ⊘

Haute couture literally means "high sewing," and these hand-appliquéd cashmere pillows follow the tradition. Wallpaper serves as the actual paper template for the wool felt pieces, which can be either hand-sewn or attached with fabric glue. We won't tell.

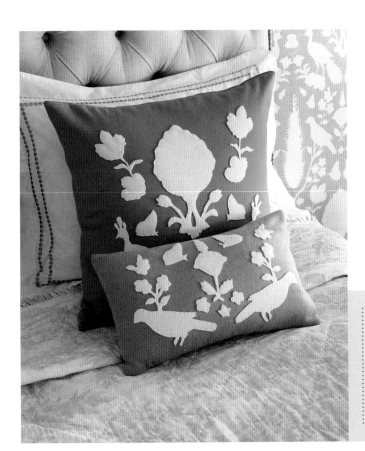

Look, there's more!

Pins be gone! Repositionable spray mount keeps patterns from slipping while fabric is being cut.

Mini-Me Designer Bedside Stand

RANKING: QUICKIE ☺☺☺

Take a dip in the kiddie pool for pint-sized replicas of highly coveted twentieth-century designer furniture—for a fraction of the price. Have fun and use them in "adults-only" spaces. Starck's Lou Lou chair (inspired by Louis XIV himself) for tots makes a perfectly grown-up nightstand.

Layering Your Lair

RANKING: QUICKIE ☺☺☺

Sometimes in couture, more is more! Layering your little lair with sumptuous mixes of fabrics, textures, rugs, and shimmering accessories elevates the luxury quotient and feeling of customized coziness. With thoughtful details, layering does not have to look bulky or cluttered—just keep Coco Chanel in mind, as it was she who reminded us all to edit. Here, a small wool mat, draped with a shearling rug at an angle, elongates the room, adding needed personality and depth to a tiny reading nook.

Leggy Bench Lifts

RANKING: QUICKIE ⏱ ⏱ ⏱

Decorative furniture feet are like the Christian Louboutins of the home
décor world. These sexy nickel-cast legs really lift and kick this ordinary
bookshelf (set on its side) up a notch to become a scene-stealing bench.

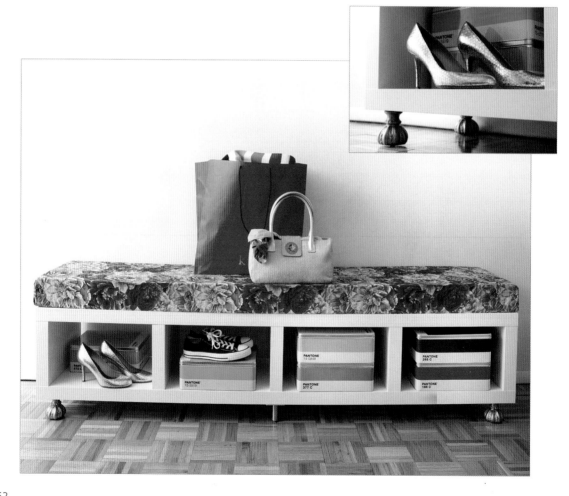

Royal Magazine Rack

RANKING: ONE-NIGHTER ⊘ ⊘ ⊘

A lowly pair of wood magazine organizers gets the royal treatment with laser-copied images of the Palais Royal. Prime the wood first (vital for a wrinkle-free finish), brush on a layer of decoupage glue, and affix paper images. Add another glue layer on top and smooth out the bubbles. Let dry and repeat for a total of three layers of glue. Gold or silver paint pen at the edges adds the crowning touch.

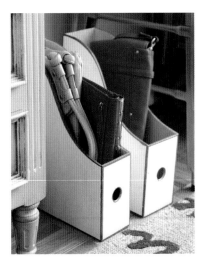

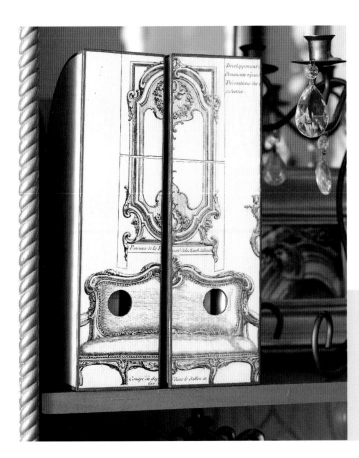

Look, there's more!

Magazine files in a closet will keep all of your clutch purses lined up and easy to see.

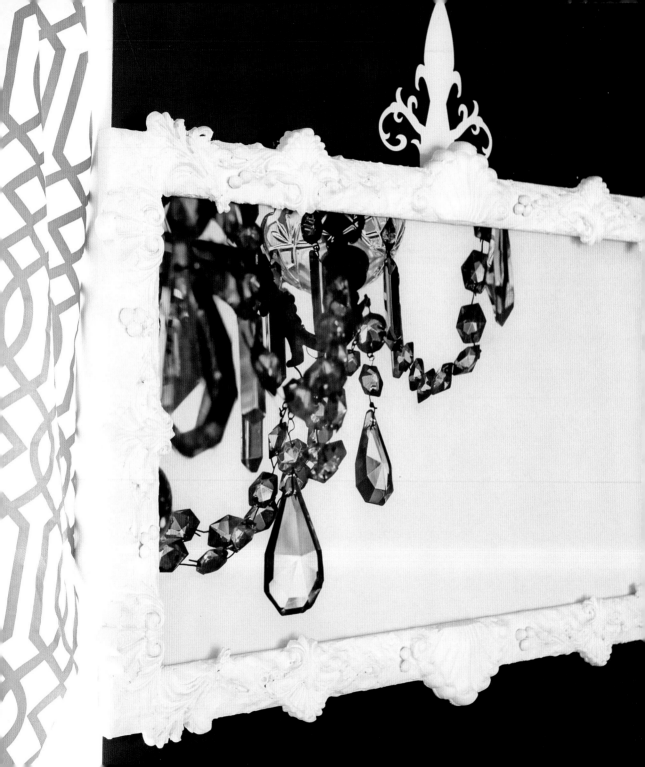

Cuckoo for Rococo Frames

RANKING: WEEKENDER ⊙ ⊙ ⊙

You say rococo. I say baroque. Either way, swirly ornate frames give any skimpy studio a big couture-style punch. Keep those steep rococo price tags at bay and make a frame yourself with polyurethane molding appliqués and instant papier-mâché. It's rococo-tastic!

How Did You Do That?

1. Start with a plain flat wood frame with a 2 ½-inch-wide molding all around. Remove the glass.
2. Choose a variety of polyurethane decorative appliqués for the corners, center top, and bottom of frame. Use hot glue to attach them to the frame.
3. Mix instant papier-mâché with water so it feels like oatmeal.
4. Fill in all of the gaps between the appliqué pieces and frame with papier-mâché. Let dry at least 48 hours.
5. Rub on a thin finishing coat of air-dry modeling clay over the front of the frame to smooth out any lumps and ensure a rock-hard surface. Let dry for 24 to 48 hours.
6. Prime with gesso and then use acrylic paint for the topcoat.

In a Nutshell

Pampering your small space with unexpected touches of glitz and glamour will delight everyone and divert attention away from a lack of square footage.

Raising the Burlap Curtain

Isn't it romantic? These dressing room curtains turn heads coming and
going—thanks to a few yards of burlap. Vertical stripes of black grosgrain
ribbon, attached with fabric glue, give them an "ooh-la-la" Parisian twist.
For more no-sew ease, finish the edges with fusible webbing and use
curtain ring clips to hang panels back-to-back.

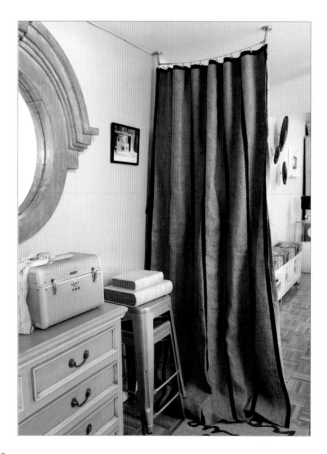
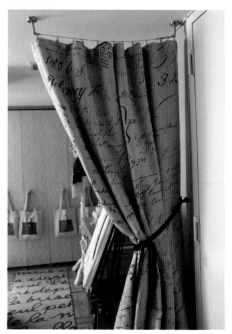

Pillow Polar Opposites

RANKING: ONE-NIGHTER ⊘ ⊘ ⊘

S-t-r-e-t-c-h your couture fabric budget by lining sumptuous silk shantung pillows with rustic burlap. The contrast of high and low textures makes a huge modern style statement in any petite space. Burlap is guaranteed to shrink, so prewash and dry before cutting the fabric.

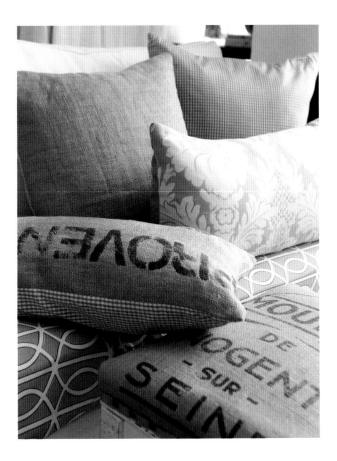

Look, there's more!

Cotton muslin lining keeps the feathers in down pillow inserts from poking through.

In a Nutshell

Thrifty burlap proves that opposites attract, playing in perfect contrast to pricier, luxurious silks and linens and maximizing every inch of your couture fabric budget.

Table Pillow Talk

RANKING: QUICKIE ⊙⊙⊙

To score these designer pillows for less, you've got to shop—in the kitchen department! Look for high-end linen place mats that are finished with a fabric backing. Since place mat dimensions (14 by 20 inches) are the same as a standard pillow, just undo one seam and tuck in a pillow form. Slip-stitch closed and voilà! The best news—one place mat costs 75 percent less than a pillow from the same collection.

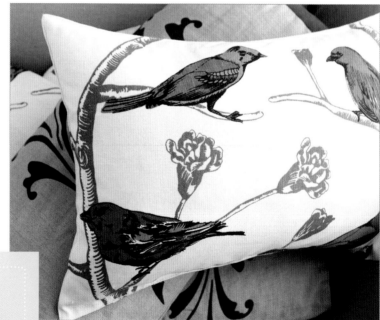

In a Nutshell

Repurpose ready-made linens for a custom-made look in a jiffy.

Custom Comforter Conversion

RANKING: WEEKENDER ⊘ ⊘ ⊘

Converting an oh-so-ordinary polyester-filled comforter into a luxurious duvet cover is like going from off-the-rack to couture. This couture-style makeover is a cinch. Open one seam on a short edge of the comforter. Use a seam ripper to remove the topstitching, take out all of the batting from inside, and wash and dry to "soften" any stitch marks. For a no-sew finish, use fusible webbing to "hem" the opened seam. Attach ribbons for closures and plump it up with a soft down blanket. Cozy couture chic!

Look, there's more!

Small ponytail holders stitched to the inside corners of the duvet cover secure a down blanket for an invisible, no-slip solution.

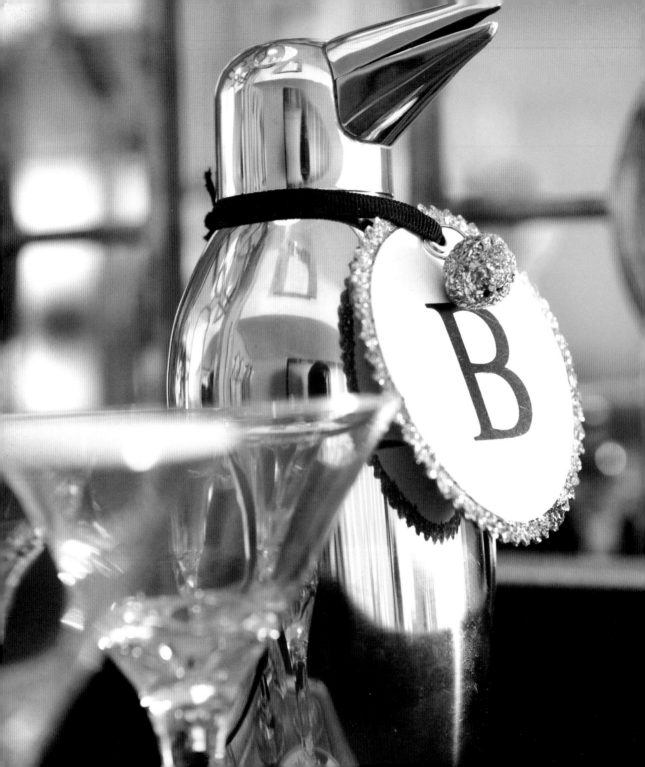

Personalize Your Nutshell

"Decorating is autobiography."
—Gloria Vanderbilt, from *The World of Gloria Vanderbilt*, 2010

Your nutshell may feel tinier than a postage stamp, but filling it with thoughtful, personal decorative details that evoke memories and a sense of history can help you overlook its limitations. Decorate with things that you love, that radiate warmth, style, a sense of humor, and comfort. Putting energy into personalizing a petite pod creates a subtle shift from the pressure of maximizing square inches to the joy of making every inch matter.

Personalizing your nutshell goes beyond the realm of decorating with a collection of framed family photographs. This chapter will motivate you to experiment with unpredictable ways to highlight and celebrate the people, places, and things that reflect who you are. You'll get ideas on how to reveal your personal side in subtle and compelling ways, even how to make a design element an interactive feature in your home that really draws people in. Keep it personal, layer in memories large and small, and you'll start to enrich and embrace the spirit of your home with individual panache.

Modern Victorian Paper Silhouettes

RANKING: ONE-NIGHTER ⊘ ⊘ ⊘

Immortalize the ones you love (including four-legged friends) on paper!
For a modern twist on a classic Victorian paper silhouette, mix and match
colors and patterns that go beyond the traditional black-and-white.
Designer wallpaper samples or gift-wrapping paper give you endless
choices for each cutout. Playing up trademark characteristics like a cute
turned-up nose, a curly ponytail, or eyeglasses adds tons of personal charm
to a paper silhouette. Each portrait is an original piece of art with a unique
story to tell, so make a few and show them off as a collection. Take profile
shots of your favorite subject and print them out on photo paper, which
will become your cutout templates. For a photo finish, use a wide picture
mat to frame the silhouette—and don't be afraid to decorate outside the
lines. Notice how a ponytail spills outside a frame for fun.

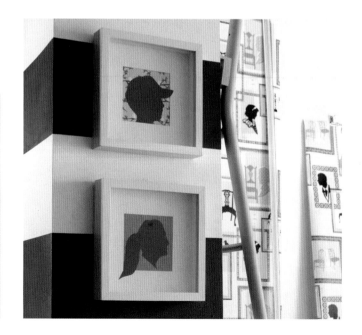

In a Nutshell

Photos and portrait art can reveal
compelling stories about their
subjects. Make yours come to life
with magnifying lenses and highlight
personalities and endearing facial
features with contrasting paper
patterns and colors.

Magnifying Picture Frame

RANKING: ONE-NIGHTER ⊘⊘⊘

Framed family pictures will be worth more than a thousand words outfitted
with vintage magnifying lenses. Attaching a bifocal lens to the outside of
a frame creates a truly intimate and compelling viewing experience. These
lenses, found on an online auction site, magnify images five to ten times
their original size and draw people in to discover the details and the history
behind a photo that might have been missed otherwise.

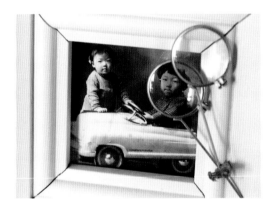

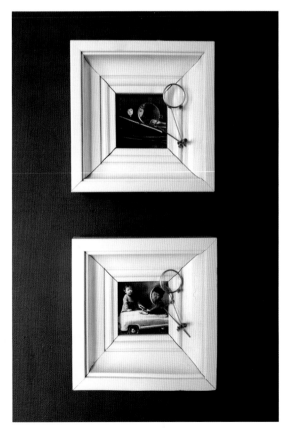

Menu du Jour Mirror

RANKING: QUICKIE ⊘⊘⊘

We'll always have Paris! Vacation photos and souvenirs enrich a traveler's home with joy and a sense of history, but you don't have to confine the celebration of those moments to a framed photograph. If you can't get a beloved Paris bistro out of your mind, relive the visit in your own kitchen. With a white liquid chalk pen (the same type used in restaurants and cafés), write out a recipe from your travels on a mirror or post a menu of memorable meals from a restaurant to transport you back in time. Unlike a regular paint pen, these pens leave behind an authentic chalky texture without the dust. Wipe clean with a damp cloth. Bon appétit!

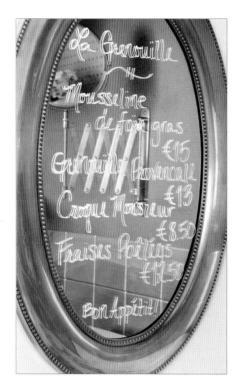
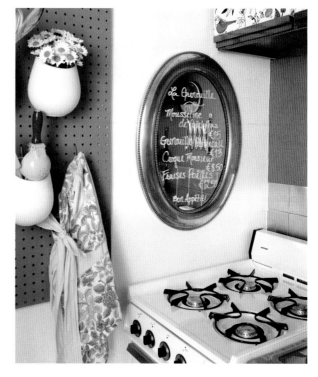

Surprise Message in a Mirror

RANKING: QUICKIE ⊙⊙⊙

Keep guests on their toes by creating interactive and amusing ways that will draw them in to discover your more personal side. If you have a memorable book passage or quote to share, print it out as a mirror image of itself, frame it, and hang it directly across from a mirror. In this intriguing little bar nook, friends can uncover an excerpt from a pulp fiction book that hints of an inner vixen.

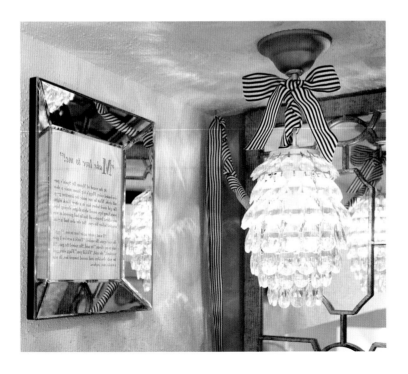

Dictionary Art

RANKING: QUICKIE ⊘ ⊘ ⊘

Look up the words *simple-chic* in my style dictionary and you'll find a picture of this framed art project. For this design idea, cut out a page from a vintage dictionary, picking a letter that corresponds to your name, your family name, or the name of a friend. Use the page as the background for a letterpress-inspired print that's made with a combination of simple rubber stamps. Your new framed art gets a personal seal of approval with a wax-stamped monogram.

Look, there's more!

Wax seals are easier to manage if you melt them separately onto aluminum foil. Cool, peel off, and glue them to your artwork.

In a Nutshell

Decorating with words, whether it's writing or reflecting a message onto a mirror, adorning a page from a vintage dictionary, or layering a favorite poem under etched velvet (see page 79), packs a powerful, personal style punch in any humble habitat.

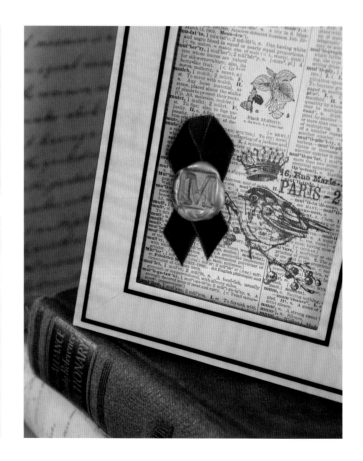

All about Me Monogram Knobs

Take it personally! A monogram is a timeless expression of personal style. The quickest way to elevate a room from generic to individually tailored is to swap out the knobs on a dresser or cabinet. This mirrored lingerie chest accessorized with glass monogram hardware takes individual ownership of a small corner with a defining personal signature.

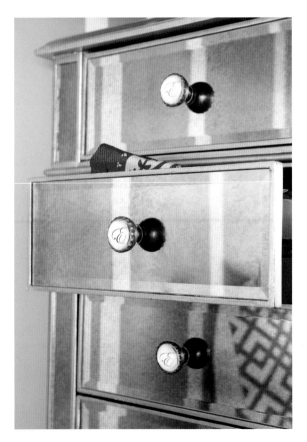

Personally-Etched Velvet Pillows

RANKING: WEEKENDER ⊘ ⊘ ⊘

If these pillows could talk, they would speak volumes on style! Fabric removal gel—available at craft stores—creates sophisticated, sheer burnout effects on velvet with the help of a blow-dryer that will have everyone guessing *designer*, not DIY. The secret to the gel is that it removes plant fibers like cotton, linen, and rayon. Apply it in a design on top of silk-rayon velvet to etch away the plush rayon pile while leaving the sheer silk backing intact. Here, a simple circle design was etched freehand on velvet. Print words or images onto a printable cotton fabric transfer sheet using an ink-jet printer.

How Did You Do That?

1. Use a brush or squeeze bottle to apply fabric removal gel in a design to the soft, plush side of silk-rayon velvet.
2. Use a blow-dryer on the wet gel design until it is completely dried.
3. Heat an iron on the wool setting. Use the warm iron and a white press cloth to press the back of the velvet design until the gel-treated areas turn a light caramel color. After cooling, the dried gel will feel stiff to the touch and can be scratched off with your finger. Drying time may vary.
4. Hand-rinse the velvet in cold water for final removal of fabric bits. Let dry.
5. Layer velvet over ink-jet–printed transfer fabric and sew into pillows.

STEP 1

STEP 4

79

Iron-Embossed Velvet Pillows

RANKING: QUICKIE ⊘⊘⊘

Ready-made velvet pillow shams purchased off-the-rack look instantly high-end and custom-designed with a family crest, monogram, or initials embossed on the front. If you know how to use a rubber stamp and an iron, you've got the designer touch needed for this project. Make sure the velvet is 100 percent rayon so the embossed image will be strongly defined. Place the soft, plush side of the velvet fabric face down on the raised design of the rubber stamp. Spray water over the wrong side of the velvet to saturate it. With a warm iron heated on the rayon-wool setting, press down firmly on the back of the fabric until slightly damp to the touch. Immediately lift the fabric from the stamp. Now, you've got a personally embossed pillow that will make you feel like a real design pro.

Who You Gonna Call?

Think of your dry cleaner as your personal neighborhood atelier. Your dry cleaner can sew pillows, hem curtain panels, and tailor fabric accessories to fit your home.

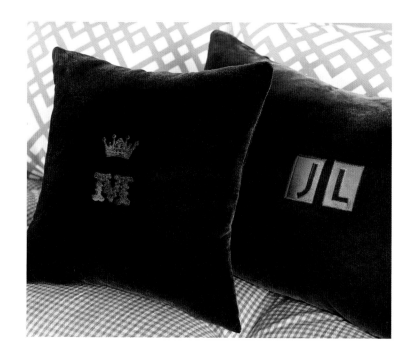

Shoe Art Bar

RANKING: ONE-NIGHTER ☺ ☺ ☺

If you're a die-hard shoe girl, you hate hiding your cherished pairs behind closed doors. Here's a chance to display your traffic-stopping sling-backs and pumps as revolving personal art on a wall. Use decorative wood molding, paint it a bright glossy color, and hang your high-heeled beauties for everyone to admire on this sassy shoe bar.

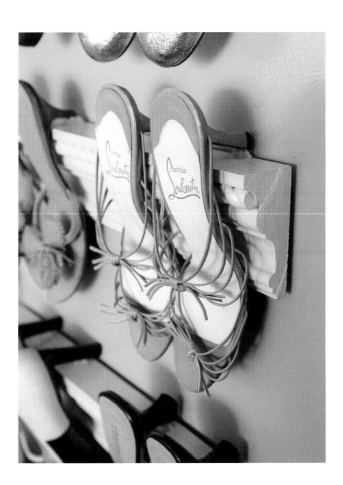

Look, there's more!

Clear adhesive rubber bumper pads keep heels from sliding off the shoe bar. Stick pads on top of the wooden bar where the backs of the heels hang.

Who You Gonna Call?

Lumberyards will precut molding for you at no extra cost. Don't be afraid to ask.

Timeless House Dressing

RANKING: QUICKIE ⊘⊘⊘

Your petite pod might land on the best-dressed list if you accessorize it with timeless pieces from your wardrobe closet. Whether you're holding on to a vintage dress, a scarf, or a pair of cufflinks passed down from a loved one, honor the memories by displaying your pieces as décor. In my bedroom, a 1950s fur jacket adorns a silk folding screen as a loving tribute to my mother (in the photo below)—my perennial style muse.

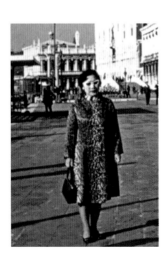

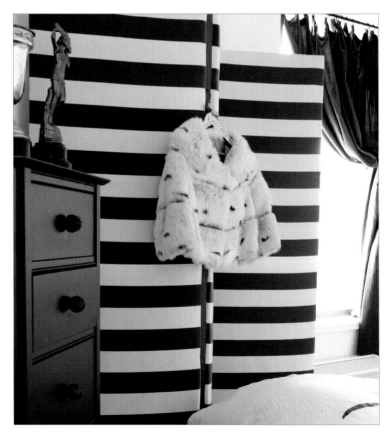

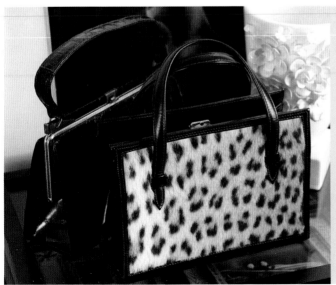

Look, there's more!

A plain wooden hanger gets to play dress-up with a satin ribbon and decoupaged French gift wrap. Now it's worthy of displaying your wardrobe faves.

A stylish grouping of vintage leopard and crocodile handbags proves there is decorating strength in numbers.

Enchanted Paper-Paneled Wall

RANKING: QUICKIE ⊘ ⊘ ⊘

No wallflowers here—rabbits, fawns, and birds are the pop-up stars of this die-cut paper in the intimate design of this bedroom. Die-cut paper panels, available in a variety of designs, add a personal touch as well as texture and dimension to ho-hum white walls. For maximum visual impact, four separate panels are hung side by side with clear thumbtacks where the wall meets the ceiling. Remember, when you are ready to roll, these panels will pack up in a flash.

In a Nutshell

Something as accessible and ordinary as paper can deliver loads of personality and warmth to a petite abode. From textured panels hung on a wall to DIY laminated butterflies, paper lets the real you shine through.

Pretty in Pink Butterfly Wall

RANKING: ONE-NIGHTER ⊘⊘⊘

Pretty-in-pink butterflies take symbolic flight on this billboard-sized wall—a real showstopper! Who knew a heat-seal laminator would be a trustworthy go-to design tool on this project? Choose a fundamental theme or motif that holds special meaning to you. For this wall design, a butterfly-shaped cookie cutter works as a template to cut out shapes from gift-wrapping paper. Press and heat cutouts between plastic laminating sheets. Cut out each butterfly and remember to fold up the wings (a ruler can help make a perfect fold) for a three-dimensional effect. Butterflies can soar in any direction by attaching them with repositionable Velcro dots to the wall. This way they'll also be ready to fly to your next nest without leaving a trace.

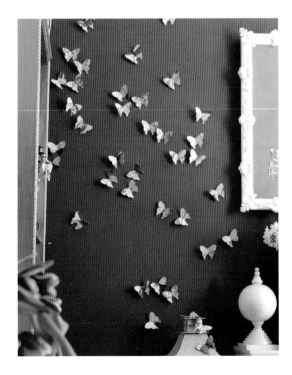

Who You Gonna Call?

A local printing shop can fulfill all of your laminating needs! For a quick guide, nine 3-by-2 ½-inch butterflies fit on an 8-by-11½-inch sheet, which costs less than a skim latte to laminate. What a steal!

Custom Window Cover-up

RANKING: QUICKIE ⊘⊘⊘

If you're tired of playing peekaboo with your neighbors across the way but don't want to block the precious daylight you get in your bathroom or bedroom, this window privacy film is a perfect camouflage cure. Digital printing houses can customize a personal message or saying onto static-cling vinyl film. All you need is a spray bottle with water to attach the film to the glass. Squeegee off excess water and air bubbles and you've got privacy plus! The added value is that the vinyl is removable and reusable, so you've got portable coverage wherever you live.

Look, there's more!

A pump or two of clear liquid soap added to your spray bottle of water will make the vinyl film easier to move around and adjust.

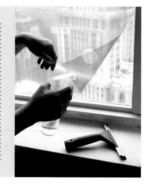

In a Nutshell

An "all about me" no-guilt design approach works in a small space with a level dose of humor and fun. Monogram your accessories and pillows or print a personal mantra on a window privacy film for neighbors to chat about.

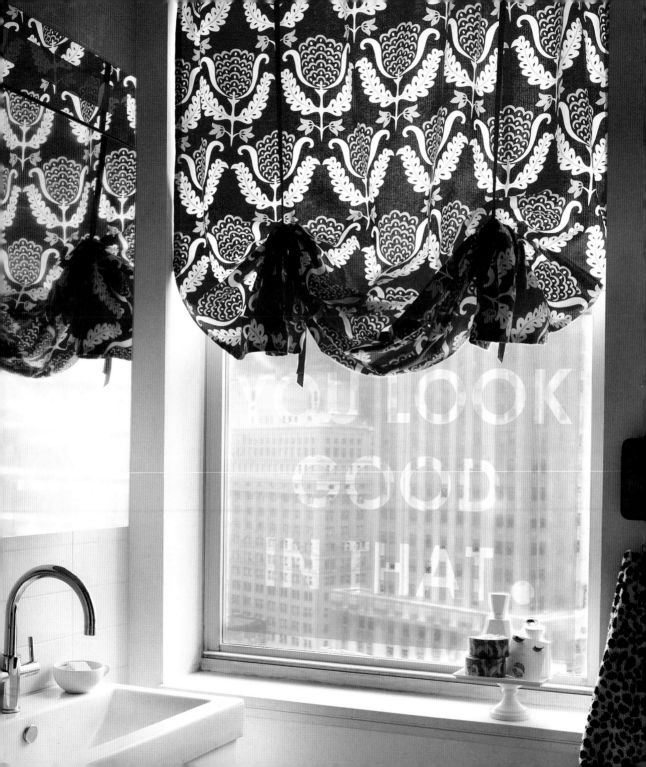

Perfectly Mismatched Nightstands

RANKING: QUICKIE ⊘ ⊘ ⊘

Remember Garanimals, the precoordinated clothing line for kids? A brilliant approach to dressing if you're three, but not the design strategy you want to take with you to your small nest. Pairing two mismatched nightstand stools puts a personal stamp on your place, builds a unique sense of character in a room, and avoids the cookie-cutter decorating rut. Instead of looking cluttered and disjointed in this small bedroom, this elephant stool and trellis-patterned nightstand are harmonious in the space. They are unified by the same glossy white finish and identical ultrafeminine porcelain lamps. Put together, the pieces in this bedroom vignette relate to and enhance each other.

In a Nutshell

Avoiding predictable pairings of furniture and accessories allows your unique personality to shine through. Mismatched pieces can still unify a design scheme with cohesive textures, themes, or color.

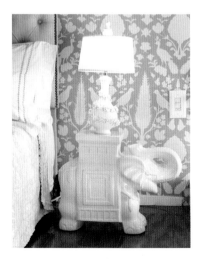

Movable Art Mannequins

RANKING: WEEKENDER ⊘ ⊘ ⊘

Breathe new life into a cast-off dress form when you transform it into a singular showcase for your favorite hobby or personal passion. Whether you've nurtured a lifelong adoration of Matisse's red poppy fields or an obsession for 1950s gossip magazines, old dress forms now get to moonlight as one-of-a-kind standing sculptures. Fashion design schools are a gold mine for bargain used dress forms. Just remove all of the fabric and batting from the form and use decoupage glue to create a collage of your favorite things. This sculpture also earns its keep holding jewelry, scarves, and hats.

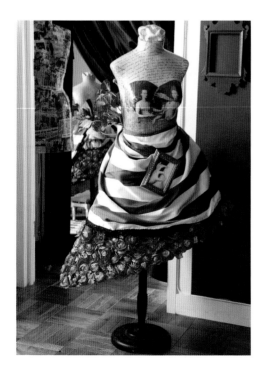

In a Nutshell

When every inch counts, look for design opportunities that combine artfulness and storage all in one.

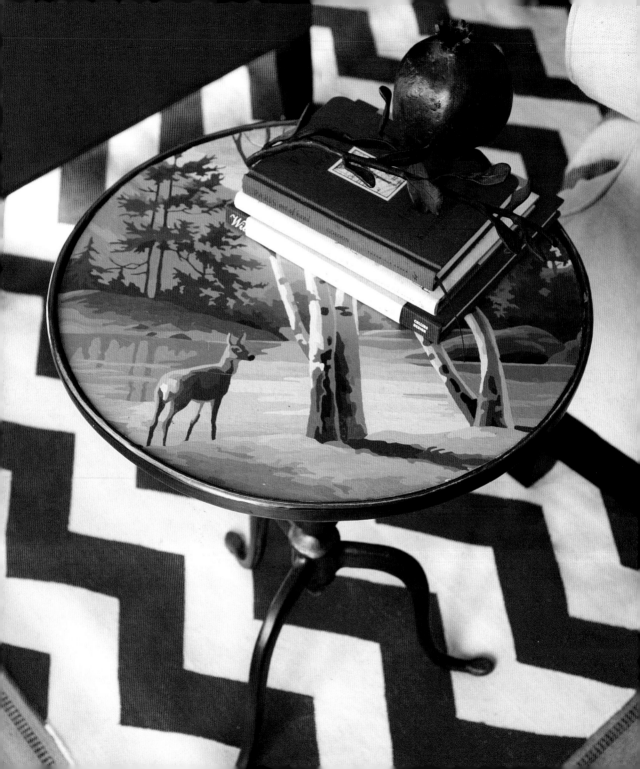

Bye-Bye Botox
Revitalizing with Vintage

"It takes a long time to grow young."
—Pablo Picasso, from *Making Time: Picasso's Suite 347*, 2006

If you feel your humble abode is looking and feeling old, dull, and tired, you might think that nothing short of a cosmetic lift can rejuvenate it. But a small dose of vintage, reinterpreted and repurposed in unpredictable ways, can give a space renewed vitality. Doing retro right is all about combining evocative pieces from different eras to create a dynamic design contrast between past and present, classic and kitsch, formal and informal. It's that tension which gives a room a modern energy and a youthful spirit.

Take a cue from the fashion world and stay away from head-to-toe vintage (or in this case, ceiling-to-floor). You'll also find that these modern do-overs of passed-down pieces don't take themselves too seriously—they infuse a small space with just the right touch of humor so that you don't feel like you're living in an antiques shop. With their timeless allure, repurposed secondhand finds accessorize a home with one-of-a-kind, offbeat charm.

Nutshell Glass Menagerie

RANKING: QUICKIE ⊘ ⊘ ⊘

Collections of timeworn, forgotten objects enjoy "Queen for a Day" status holding court under a glass cloche or bell jar. A group of vintage white porcelain nuts (sprinkled among plastic nuts painted metallic silver) creates an avant-garde still life that will make you stop for a closer look. Placing the cloche on top of a glass pedestal base gives this vintage collection a modern, elegant lift.

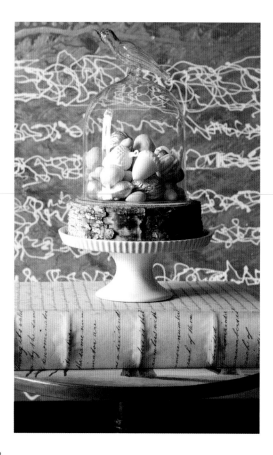 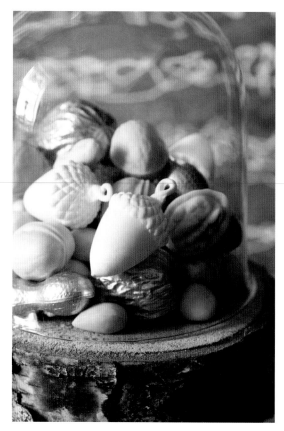

Letter-Perfect Double-Paned Display

RANKING: QUICKIE ⊘ ⊘ ⊘

Layer vintage displays under more than one glass container for a striking updated look. Antique letterpress woodblocks, showcased in vintage glass apothecary jars and inkwells, are doubly stylish standing tall under a dramatic contemporary glass cloche.

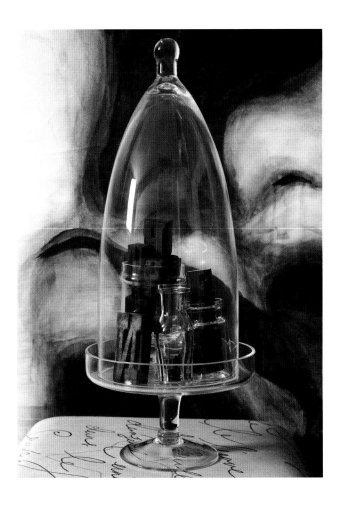

In a Nutshell

Augment small vintage collections of rare items that are difficult or costly to obtain in a clever and decidedly less serious way by mixing in cheaper, present-day knockoffs. Showcase the new members of the group using bold splashes of color or metallic finishes, or put them under a glass display to usher an old collection into the twenty-first century.

Vintage Trophy Redux

RANKING: QUICKIE ☺ ☺ ☺

"First, I'd like to thank the Academy. . . ." You might not have an Oscar on your mantel, but chances are you've got a trophy or two from an old school swim meet or a bowling tournament collecting dust somewhere. Here, a collection of vintage metal beauty pageant trophies is reinvigorated by a pop art combo of inexpensive plastic trophies spray-painted a vibrant turquoise.

Look, there's more!

Engraving is free from most trophy and award companies, so go ahead and personalize trophies with your name and town and make up a silly title for the award you happen to sweep first place in.

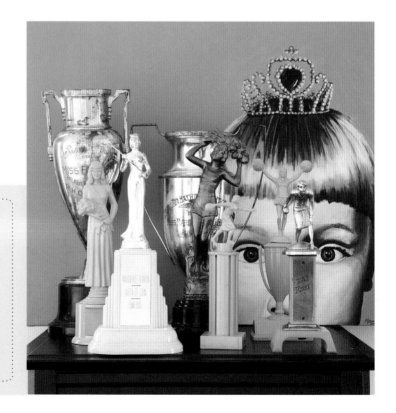

Sunny-side Up Egg Basket Lampshade

RANKING: WEEKENDER ⊘ ⊘ ⊘

For a fresh update on a weathered classic, sometimes you have to turn vintage on its head. An antique collapsible wire egg basket, hung upside down and fitted with a plug-in lamp cord, becomes a pendant lamp that casts an original retro-modern industrial glow on your space. Generic manila office tags, stamped with travel images and hung like crystals on a chandelier, revive this basket with unexpected whimsy. Bendable aluminum craft wire keeps the lamp cord in place, and black grosgrain ribbon wrapped around the cord gives this lamp presence and loads of personality.

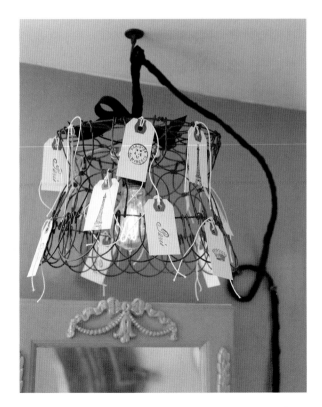

Cocktail First-Aid Kit

RANKING: QUICKIE ⊘ ⊘ ⊘

Don't panic because of impromptu party emergencies. Keep a spare corkscrew at the ready (there's also room for a small jar of olives) in a telephone tin box from the 1940s. A removable adhesive hook keeps the corkscrew handy. Your guests will get a kick out of being in on the secret.

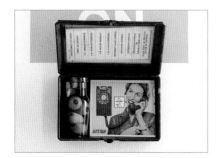

In a Nutshell

Artfully introducing vintage metal pieces into a contemporary space is a classic design strategy that you can rely on. Whether it's an old-fashioned wire egg basket or a faded first aid tin, retro metal is built to last, and "upcycling" it in an unexpected way can give a previous castoff a greater style value in its second life.

Trustworthy Scout Storage Tins

RANKING: QUICKIE ⊘ ⊘ ⊘

Scout's honor! You'll earn a special merit badge for creativity by breathing new life into vintage Boy Scout and Girl Scout first aid tins (from the 1940s and 1950s). Use these quirky storage catchalls on a bathroom wall to store cotton balls and nail polish, or keep one on a nightstand to tuck away a TV remote. Removable adhesive strips are strong enough to hang tins in place until you're ready for that next scout outing.

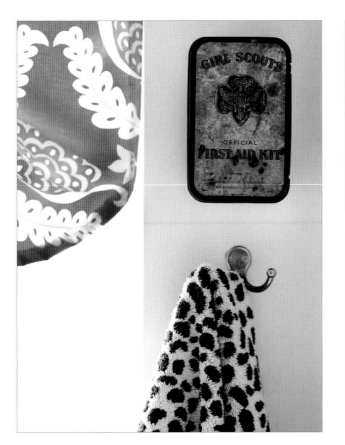

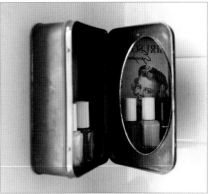

Look, there's more!

Lipstick check! Attaching a small mirror to the inside of a Girl Scout tin turns it into the perfect pit stop to apply your lip gloss, stash it— and dash out the door.

Paint by Number Table Topper

RANKING: QUICKIE ⊘⊘⊘

Channel your inner Rembrandt! Paint by Number canvases, an instant hit when they debuted in 1951, are deserving of a comeback with a slightly contemporary attitude—call it kitschy modern-chic. This industrial pewter table gets a mini facelift with a vintage Paint by Number canvas table topper. The storybook woodland scene paired with a modern metal table provides just the style contrast this urban apartment needs to look current. Canvases are usually made from a thin piece of chipboard and are easily cut to size with a craft knife. The new topper stays in place on its own with no need for glue or tape, and a little spray of matte sealer keeps it protected. Collect a few masterpieces and swap them in and out to fit your mood or the seasons.

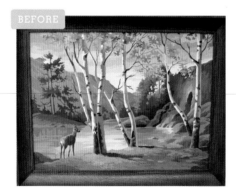

BEFORE

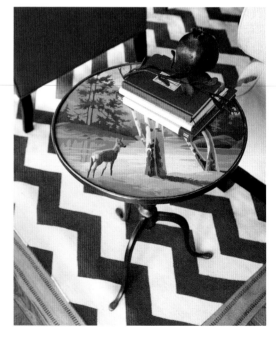

Look, there's more!

Vintage Paint by Number canvases can be cut to fit onto the fronts of drawer panels to embellish a nightstand for a custom finish. The drawer pull keeps the art panel in place, and double-sided tape makes it extra secure.

In a Nutshell

Handcrafted items lend warmth, individuality, and a sense of history to any space. Repurposing passed-down novelties, like kitschy Paint by Number canvases, and playing them against sleek, modern surfaces is an unexpected move that lightens the formality of a room.

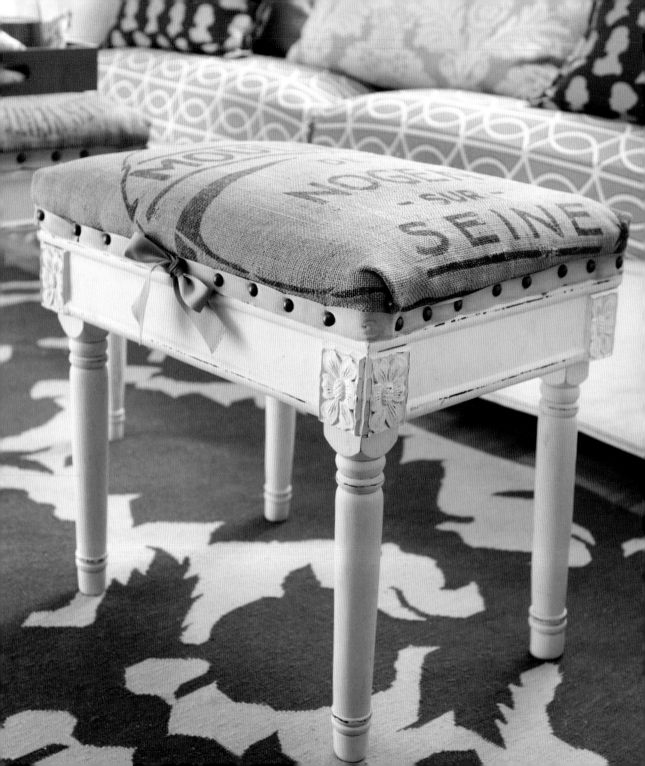

One Hundred Percent Whole-Grain French Stool

RANKING: ONE-NIGHTER ⊘ ⊘ ⊘

There is a French farmer somewhere out there having the last laugh at the surge of vintage French burlap grain sacks adorning everything from chairs and stools to lampshades. These repurposed grain sacks date back to the 1950s and 1960s, and the different logos on each give the pair of stools that eclectic, modern edge. Keep an eye out for burlap sacks that are double-printed on the front and the back to get even more style mileage for the money.

How Did You Do That?

1. Measure and cut a burlap sack to fit the top of the stool, allowing an extra 1½ inches all around to tuck under.
2. Set the burlap on the stool, fold under the raw edges, and cover the edge with grosgrain ribbon. Use T-pins to temporarily keep the ribbon and burlap in place.
3. Hammer in decorative upholstery tacks to attach ribbon and burlap to the stool, removing the T-pins as you go.
4. Finish with a bow on both sides. Tie each bow from a separate piece of ribbon and tack in place.

Military Chic Blanket Stool

RANKING: QUICKIE ⊘ ⊘ ⊘

This footstool earns its stripes in utilitarian chic! Upholstered in a vintage Italian military blanket, it can hold its own on the style front lines. Feminine touches like the velvet ribbon and floral embossed molding make this sixty-five-year-old blanket look like a trendy senior hipster. Pure wool vintage military blankets (Italian and Swiss are favorites) are affordable and durable and, because of their dense weight, are the ideal candidates for upholstery duty. They can be found at army-navy stores and online outlets for European military surplus. Just a heads up—most blankets like this have been stored and preserved with mothballs, and dry cleaning will only set the scent permanently. Airing out a blanket in the sun for a few days will give it a fresh start. Attach with upholstery tacks and you've got a no-sew victory.

In a Nutshell

Be on the lookout for vintage utilitarian and military goods with a masculine past like burlap grain sacks or army blankets and repurpose them as hardworking and enduring upholstery fabrics for your home. The key to creating a contemporary, cool look is to pair these rugged fabrics with their polar opposites—details and textures that are feminine, sleek, and modern.

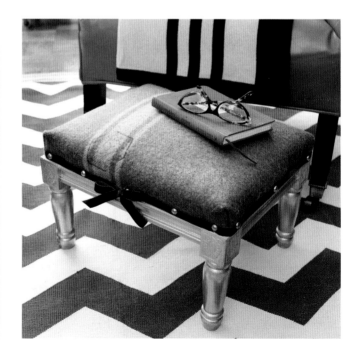

Blueprints under Glass

RANKING: ONE-NIGHTER ⊘ ⊘ ⊘

Here's a blueprint for a truly winning console or coffee table. Give authentic architectural house blueprints designed in the 1950s (found at flea markets and online auctions) a renewed life in your home as contemporary accents under clear glass or Lucite tabletops. Cut a blueprint to fit the surface and attach face up under the tabletop using repositionable craft glue dots. Blueprints that were originally drafted for a family's dream home can bring true heart to any space.

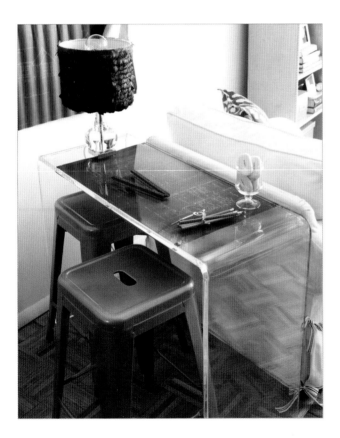

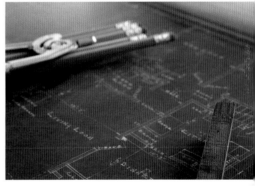

In a Nutshell

Glass or Lucite tabletops can serve as revolving art displays of eye-catching treasured mementos while offering protection at the same time.

Lighten Up

"All right, Mr. DeMille, I'm ready for my close-up!"
—Gloria Swanson, as Norma Desmond in *Sunset Boulevard*, 1950

Good lighting might not have rescued the mad character Norma Desmond in *Sunset Boulevard*, but award-worthy lighting can cast its transformative magic on dimly lit digs, enveloping them with depth, drama, opulence, and warmth.

No room, even one with pint-sized proportions, can reach its fullest design potential with one light source alone—so think "fill, accent, and glow." First on the lighting to-do list—set up a winning combination of multiple light fixtures that fill the room with soft ambient light. You can do this by angling main light sources upward to bounce off the ceiling, which visually heightens a vertically challenged space. Then throw accent and task lighting into the mix, and you'll start to illuminate and define forgotten work, play, and rest zones. Adjusted at different heights and angles, accent lights have the style wattage to perpetuate a sense of depth and dimension in a flat space.

Designers refer to "fill" and "accent" as the primary layers of light in a room. The glow factor amplifies the effect, so think of that layer as the shimmer and shine that radiate from reflective mirrors, glass, crystal, and silver. These finishing accent pieces play off one another with a twinkly light that won't put a dent in your electric bill.

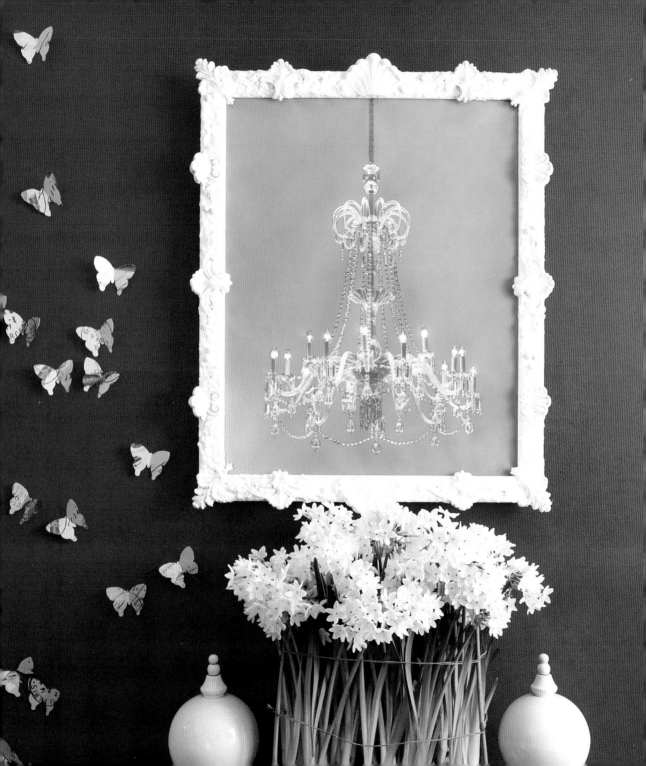

Chandelier Light Box

RANKING: ONE-NIGHTER ☺ ☺ ☺

Every small space deserves a glamorous chandelier, but it's nearly impossible to find one that is luxe, portable, and skinny enough to squeeze into a slim spot. Inspired by a photographer's light box, this stylish, smart stand-in illuminates a space with a simple string of battery-operated LED lights. Transfer a photo of a chandelier onto transparency film made specifically for lighting images from behind. Attach the printed photo onto an artist's canvas, secure the lights on the back, and you've got instant sparkle. When this fabulous faux chandelier light is off duty, it still shines as an original piece of wall art.

How Did You Do That?

1. Buy a prestretched artist's canvas that measures 1⅝ inches
2. deep, or deep enough to hide an LED light battery pack.
3. Have your local digital printing shop make a color copy of your chandelier photo onto a piece of Duratrans color transparency material, measured to the exact size of your canvas.
4. Staple the photo image onto the front of the canvas within ¼ inch of the edge. The staples will be hidden under the decorative frame, attached later.
5. Turn the canvas over and hold it up to a light or a window. With the shadow of the chandelier image on the front as a guide, use a pencil to lightly mark the position of each arm of the chandelier that you want illuminated.
6. Attach a small string of LED lights (they will stay cool to the touch) onto the back of the canvas with white gaffer's tape, grouping one or two bulbs over each pencil mark.
7. Tape the battery pack to a lower inside corner of the stretcher frame, leaving the power button free and accessible.
8. Set a decorative rococo frame (see How Did You Do That? on page 65) over the print and secure with offset mounting canvas clips. You'll need these clips because the canvas is deeper than the picture frame.

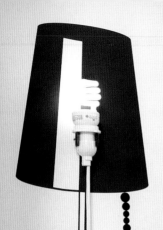
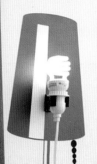

EAT MORE
VEGGIES
FLOSS
RECYCLE
TIP BIG
SLEEP IN
USE
SUNSCREEN
BE
PRESENT
TEXT
LESS.

Standing Room Only Decal Lamp

RANKING: QUICKIE �’⌕⌖

If you don't have an inch to spare in your cozy nook but are desperate for more illumination, this "peel-and-stick" floor lamp can fit in some pretty tight corners. With a simple removable floor lamp wall decal and a lightbulb cord, you've got light—without taking up any floor space. A plastic flashlight wall caddy cradles the lightbulb to the wall, and black felt furniture pads fill in as a make-believe pull chain. You'll find CFL bulbs work best since they don't emit enough heat to melt the decals.

In a Nutshell

Lighting for tiny digs that is slim, smart, stylish, and portable is as close as your local printing shop or an online wall decal site. With very little DIY commitment (if you can staple and put in a screw—this is for you), you get big lighting solutions.

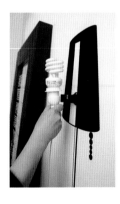

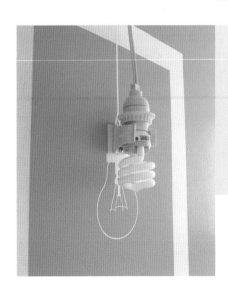

Look, there's more!

Low ceiling? In this bedroom loft, white decal pendant lights work miracles to brighten up a teeny spot, without leaving a footprint.

Plug In and Go Pendant Lamp

RANKING: QUICKIE ⊘ ⊘ ⊘

For tiny dwellings, hanging lamps are essential multitaskers. They free up valuable table and floor space while casting warm pools of light from above. If you can't commit to hiring an electrician to rewire your home or drill holes in the ceiling, do a little conversion on your own. This crystal pendant chandelier was easily refitted with a plug-in cord for flexibility. It's like having lighting to go! A striped ribbon dresses up the unsightly lamp cord.

Look, there's more!

Lamp cords come in vibrant colors and patterns. They can replace ugly industrial cords and become unexpected, modern design features. If you're not up for a complete lamp cord rehaul, wrap the cord in ribbon for a polished finish. Suspending a group of two or three cords so that the lamps fall at different heights will illuminate any dark corner with pizzazz.

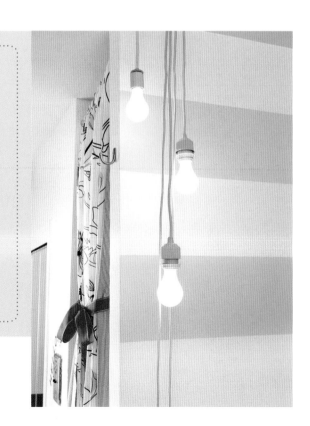

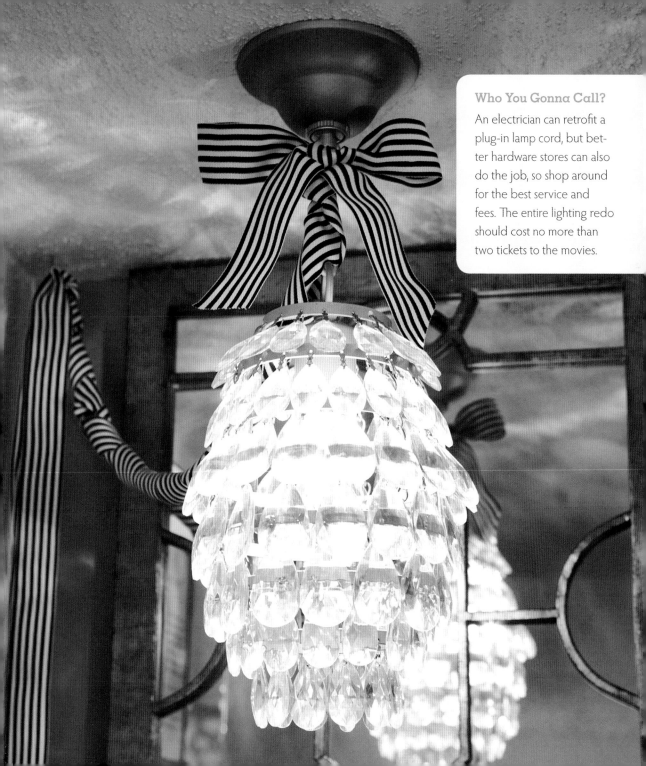

Who You Gonna Call?

An electrician can retrofit a plug-in lamp cord, but better hardware stores can also do the job, so shop around for the best service and fees. The entire lighting redo should cost no more than two tickets to the movies.

Recession-Free Adaptor Light

RANKING: QUICKIE ⊘⊘⊘

Say good-bye to ugly recessed lighting! Inexpensive adaptor kits can convert recessed lights into stylish pendant lamps that will enable you to put your personal stamp on the place. There's no hardware to deal with, no drilling, no nailing—no kidding! Just take the bulb out of the recessed light socket and screw the adaptor in its place. Add your own custom shade and you're in business. Remember to pack it up for your next space.

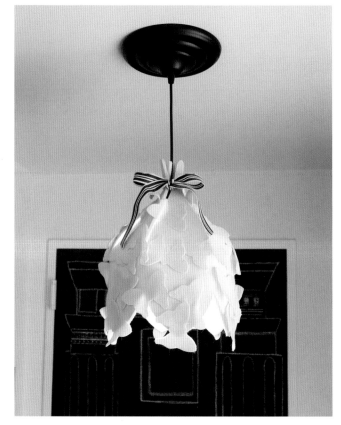

In a Nutshell

Pendant lamps radiate the most style and shine per square inch of space in the smallest of flats. Now, plug-in and screw-on adaptors make them easy to install and move from room to room.

Fade to Fabulous Dimmer Lights

RANKING: QUICKIE ⊘ ⊘ ⊘

Lights without dimmers are like radios without volume control. Dimmers give you the ability to soften or brighten a room, define nooks and crannies, and fine-tune the mood and drama of a space at the touch of your fingertips.

◇◇◇

In the Pink Lights

RANKING: QUICKIE ⊘ ⊘ ⊘

Think pink! Expensive custom lampshades are often lined with pale pink silk for the flattering glow they reflect in a room. But who has the budget for that, right? Instead, use soft pink lightbulbs. The subtle blush tint casts a warm color tone that is complimentary to your complexion and décor. Flip the switch in your bedroom and go pink for soft reading light that's easy on the eyes. Pink bulbs are also miracle workers near a bathroom vanity mirror—you'll feel pretty brushing your teeth.

Past Perfect Lightbulb

RANKING: QUICKIE ⊘ ⊘ ⊘

This flash-from-the-past reproduction lightbulb really sets a magical glow to a room. The cool twists of the filament make this bulb look new again paired with a modern lamp or sconce. Thanks, Thomas Edison!

In a Nutshell

Everyone living in a light-deprived nutshell needs an arsenal of super-quick, reliable lighting fixes to set a welcoming mood and cast a warm glow. Using dimmers and flameless candles is as easy as changing a lightbulb—and don't forget to accessorize with a few retro and pink bulbs while you're at it.

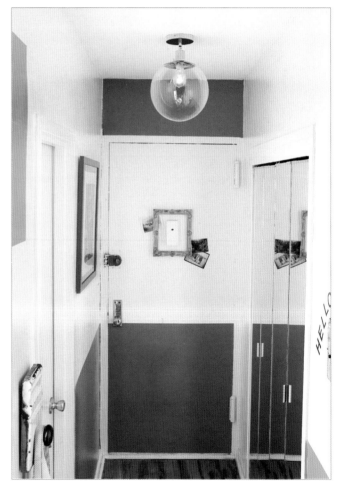

Burn-Free Candles

Think of candles as the Prozac of the decorating world—it's hard to feel blue in a room drenched in candlelight. Thanks to flameless battery-operated candles cast in wax (complete with blackened wicks), you can put the glimmer of candlelight safely where flame candles could never go before. Pillar candles and tea lights add luminance to bookshelves, windowsills, even along staircases—places too risky for the real thing.

Look, there's more!

Flameless candles wrapped in genuine birch bark sheets say Adirondack chic and will throw everyone off the faux candle trail. Thin birch sheets are available at floral and craft stores. Just soak the sheets in water to make them pliable, wrap them around each candle, and secure with double-sided tape or tie with twine.

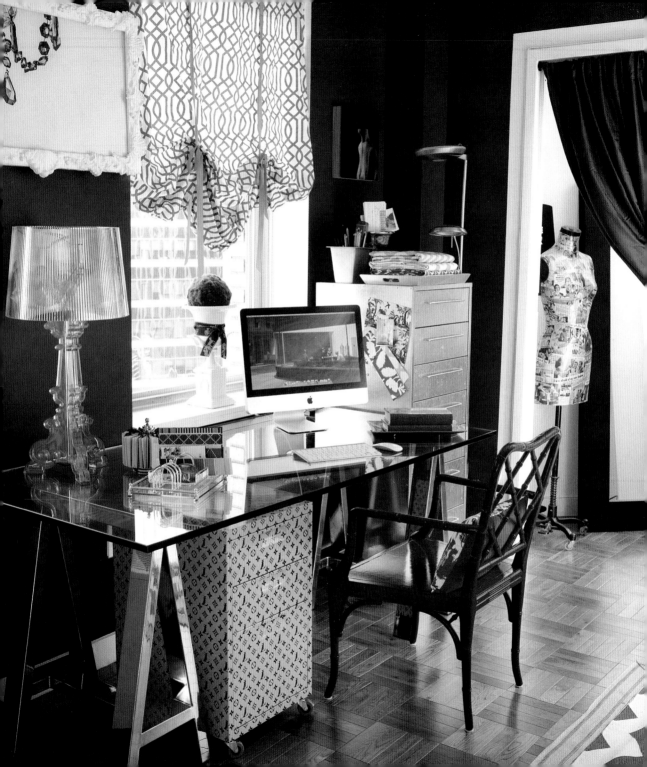

Glass Desk

RANKING: QUICKIE ⊘ ⊘ ⊘

In a pint-sized pied-à-terre, feel confident to super-size furniture and accessories with reflective surfaces like this large 6-foot glass desk. It may be long and wide, but since it doesn't take up any visual real estate, this petite living room (which doubles as a home office) looks clutter-free and open. Standing in as an indispensible buffet and dining table at parties, this multitasking glass desk earns its keep as a small-space essential. The super-sized acrylic desk lamp completes the see-through chic theme.

Look, there's more!

Clear Lucite and acrylic furniture seems to recede into the background yet still maintains a trendy edge in a space. Because the surface is not cold and fragile like glass, these fantastic plastic pieces are great to use in a child's room.

Mirror, Mirror on the Book Wall

RANKING: ONE-NIGHTER ⊘ ⊘ ⊘

It only takes a little mirror magic to double the perception of light and space in a room. Here, lining the back of just one bookshelf with a mirror was enough to make a brilliant impression. The trick is to place the bookshelf opposite a window or light source. Shop around to find ready-made mirrors and mirror tiles that will be a close fit to your bookcase. Or, for a no-fuss approach, lean a cluster of mirrors against a bookshelf.

In a Nutshell

When it comes to adding shimmer and shine in a small spot, layer on the glow factor. Not every accessory or decorative element can be the featured star in a room's design. Supporting players like high-gloss paint finishes and mirror-backed bookshelves are key to enhancing overall drama.

Look, there's more!

Metallic wallpaper teams up with mirrors to maximize luminosity and sparkle.

Reflective and Pearlescent Paint

RANKING: WEEKENDER ☺ ☺ ☺

Paint your petite pad! Choose colors and finishes that reflect light in the most enchanting way. Layer high-gloss and semigloss finishes, usually reserved for trims and doors, onto walls and ceilings. Look for paints specifically made to give off a pearlescent glimmer and brush them on walls opposite a mirror for luminosity that is subtle and alluring, day or night.

Looking Through the Mercury Glass

RANKING: QUICKIE ⊙⊙⊙

In the nineteenth century, mercury glass was thought of as poor man's silver; critics complained that it looked more like reflective mirror. Today, this shimmery, glistening quality is exactly what makes mercury glass the must-have collectible for small spaces. Cluster vases and candleholders in a dazzling display and see how they pick up and reflect beams of light in dim corners.

In a Nutshell

Go big, bold, and multiple with shiny, reflective décor and accessories. When pieces are "see-through" or metallic, they reflect sparkle and shine back into tight quarters. Everything will look and live larger!

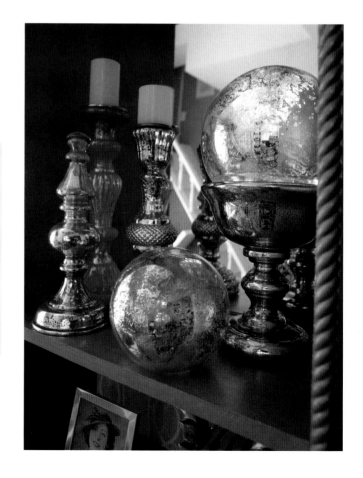

I Spy Style Mirrors

RANKING: ONE-NIGHTER ⊘ ⊘ ⊘

Call security! This is a design idea everyone will want to steal. Use industrial convex security mirrors, usually found in parking garages, in your home as cool, modern decorative mirrors. In this hallway, a trio of convex mirrors allows for a wider range of view than a single flat mirror and captures natural light from the apartment's only window.

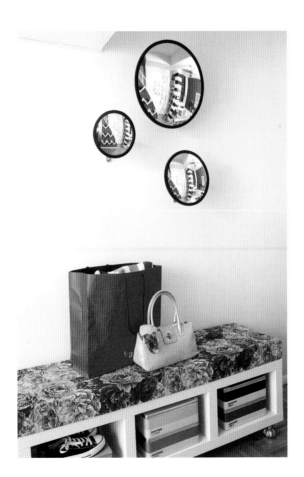

In a Nutshell

Industrial and cosmetic mirrors outside of their expected settings keep the décor fresh while amplifying light and space.

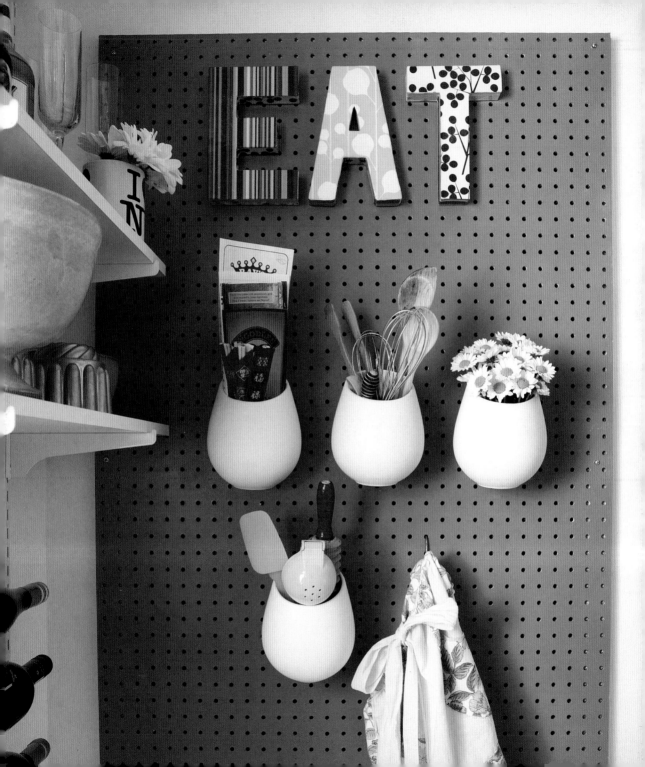

Tag, You're It
Labeling and Organizing

"I could be bounded in a nutshell and count myself a king of infinite space..."
—William Shakespeare, *Hamlet*, Act I, Scene II, c. 1600–1602

For the past twenty years, I have lived in 750 square feet or less (many of these teeny spots were shared spaces, by the way) and have fought the good fight against the dreaded "C" word—clutter! The upside to living and working in a nutshell is that it really forces you to edit what you own and whittle it down to the stuff that matters most. I'm not talking about living a minimal life or giving up cozy creature comforts but about getting creative with storage and organization. Storage solutions that are cool and stylish yet practical are more a pleasure than a chore to maintain and offer some level of instant gratification every time you use them.

You might be used to thinking about storage in black-and-white terms—it's either hidden or open. But the clutter-busting solutions in this chapter also venture into that gray area I call "delightfully undercover" storage. All of your belongings are easily accessible and out in the open but sit with such panache, they just blend in with the décor.

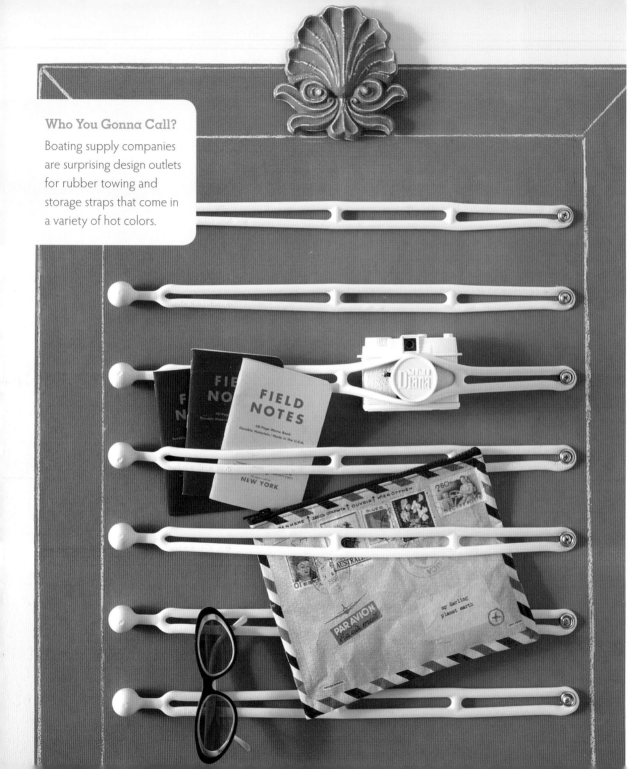

Who You Gonna Call?

Boating supply companies are surprising design outlets for rubber towing and storage straps that come in a variety of hot colors.

Home Stretch Wall Storage

RANKING: ONE-NIGHTER ⊘ ⊘ ⊘

It's easy to let a catchall corner run amok. These white rubber boating straps maintain their cool while keeping everyday essentials like keys, mail, sunglasses, even cameras from taking over a foyer. Boating straps are extra strong, happily won't mar or scratch, and look graphic and trendy in multiples. Simple screws and washers keep the straps in place. Give them a whirl in a kid's room or put them to work in a home office as a hip storage alternative.

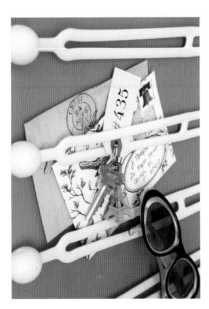

In a Nutshell

If you're really pressed for storage space, maximize your vertical real estate when it comes to organizing your daily go-to items like keys, bills, and your clutch. Whether it's hooks or rubber straps, storage hardware hung in multiples makes anything they harness look pulled together and opens up valuable table space.

Chalk It Up Holding Bins

RANKING: QUICKIE ⊙⊙⊙

When there's nowhere to hide them, give storage bins a sharp, cohesive designer look with orange chalkboard painted tags and brown ribbons. Once available in black only, chalkboard paint now comes in a rainbow of vibrant colors. Use a generic office tag as a template to paint these write-on labels. You'll be creating a system that always keeps a tidy edge and is flexible enough to shift with your changing storage needs.

Look, there's more!

A regular pencil sharpener maintains a precision point on chalk to help you show off your handwriting finesse.

Chalky Thoughts Pet Corner

RANKING: QUICKIE ⏱ ⏱ ⏱

There's only one thing on this cat's mind. Now you can post your pet's inner monologue on a DIY chalkboard—a lighthearted touch that defines and organizes the pet zone in your space.

In a Nutshell

When they are forced out into the open, haphazard boxes, bins, and even pet food areas can take over a small space. A quick way to tame essential but bulky storage containers is with whimsical labels or colorful tags. Chalkboard paint is a practical, cheerful design option for write-on tags that are easy to update.

Open Kitchen Plan

RANKING: QUICKIE ⊘ ⊘ ⊘

In cramped kitchens where cabinet space is at a premium, you sometimes have to go public and display your wares on open shelving. Rather than thinking of it as boring storage, consider open shelving your very own mini store showcase. For a sleek boutique look, group glasses and dishes by color, size, or texture. Turning the handles of cups and teapots in the same direction unifies the display, while propping the collection up onto footed platters of various heights focuses the eye on humble housewares. Open shelves make a kitchen feel welcoming, so invite guests to grab their own coffee mugs or dessert plates and help themselves.

Look, there's more!

Topsy-turvy stacks of dishes and footed platters stay put with reusable adhesive putty or clear museum gel. Now, displays can reach great heights for added drama.

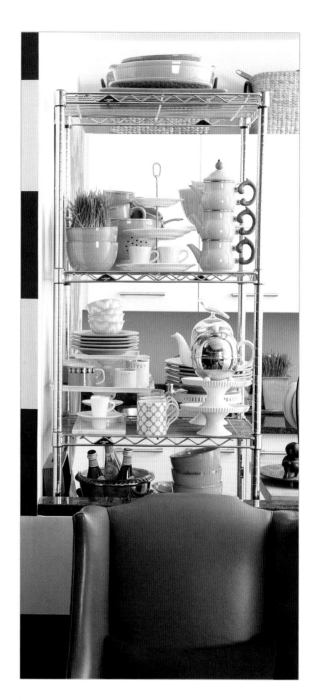

Off-the-Rack Wine Shelves

RANKING: ONE-NIGHTER ⊘ ⊘ ⊘

Ho-hum bookcases can easily step in as modern wine racks. These zigzag bookcases are the ideal size to hold a full collection of a favorite vintage while freeing up cabinet space.

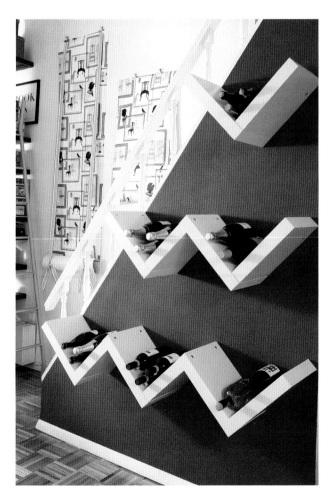

BEFORE

In a Nutshell

Open shelving looks cool, calm, and collected with one key theme to pull the look together. A wine rack is easy to style and stock, but for open kitchen storage, take the items you use the most and organize them in groups on a large table. You'll discover a design narrative—whether it's colors, shapes, or function—to unify your display.

Bijou Box

If you're a jewelry girl at heart, an armoire dedicated to your favorite accessories is a dream come true. Lifting this old armoire off the ground and onto the wall opens up a corner in this boudoir. Adorning it with plain wooden appliqués and pearlescent lavender paint will fool everyone into believing it was custom-made just for you.

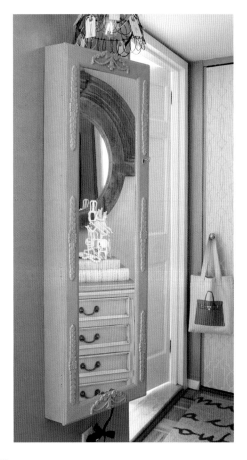

Tiptoe through the Tulips

RANKING: QUICKIE ⊘⊘⊘

Seems like storage can never be too tall or too thin when it comes to tiny spaces. With just 12 inches to spare, this statuesque yellow vase, called a *tulipière*, heightens and brightens a petite alcove measuring just under 5 feet. During the seventeenth century, a tulipière was a sophisticated way to display cut tulip stems. Today, each separate compartment of the vase organizes mementos and other trinkets while keeping the look long and lean.

◇◇◇◇◇◇◇◇◇◇◇◇◇◇◇◇◇◇◇◇◇◇◇◇◇

Time Traveler Train Case

RANKING: QUICKIE ⊘⊘⊘

Capture the romance of the rails with vintage train cases that evoke journeys past. These cases, a staple at flea markets, offer a full-service vanity with mirror and pockets to store cosmetics and hair appliances. Put your personal stamp on a vintage train case with antique bronze alphabet brads (under the key hole at right) affixed with just a dab of glue.

In a Nutshell

Girly girls, rejoice! Instead of hiding makeup and jewelry collections in ugly boxes and dreary medicine cabinets, keep these go-to items in quirky containers that are easily accessible yet stylishly under the radar. Being organized and in control has never been more fun!

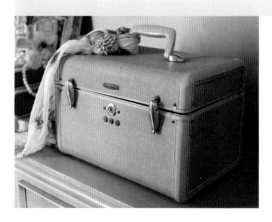

Now You See It, Now You Don't Folding Screen

RANKING: WEEKENDER ⊘ ⊘ ⊘

A folding screen can hide all the necessary evils lurking in a small space. Old wooden doors hinged together get a style revamp with silk taffeta to become a retrofitted screen that works doubly hard. An entire season of shoes is stowed away on the reverse side in muslin over-the-door shoe bags attached with thumbtacks. Little hooks hold a laundry bag and keep it out of sight. No one will be the wiser.

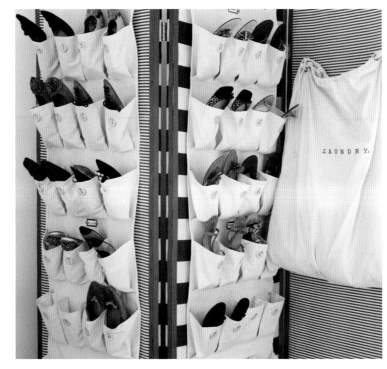

Shoe Tag, You're It!

Tag it and you will organize it! Yellow office key tags officially take on shoe organization duty with rub-on numbers so you don't lose count of a single precious pair.

How Did You Do That?

1. Remove the ring from a yellow paper key tag.
2. Use white or black rub-on numbers to label each tag.
3. Push a large metal brad through the hole in the tag and pierce a hole into the muslin shoe pocket. Spread the prongs of the metal brad open to secure it in place.

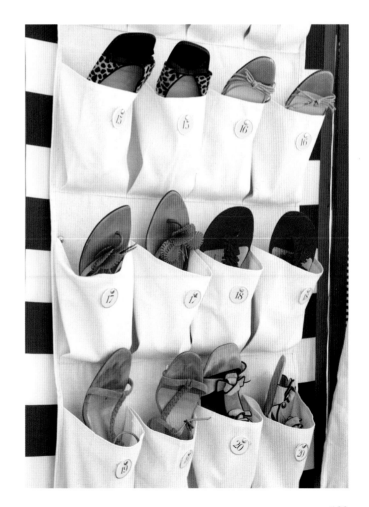

May I See Your Shoe Photo ID?

If you need to keep tabs on an expanding shoe collection, store your favorites by season and tag them using this fresh take on the old classic Polaroid photo shoe label. Snap an arty close-up of the particular feature or detail that made you fall in love with the shoes in the first place. Print out images on adhesive transparencies and stick them to cardstock tags. The transparencies are repositionable so you can easily swap out and upgrade photos without damaging the tags—perfect when you add your next sexy pair of Manolos to the mix.

In a Nutshell

A girl can never have enough shoes or enough shoe storage. Being able to see every pair that you own is the secret to maintaining any system of organization. Whether you use candid shoe photos or hanging shoe pockets (with shoe tips instead of heels sticking out for easier identification), arranging subgroups by season or occasion will speed up shoe selection.

Vincent van Gogh Portable Vanity

RANKING: ONE-NIGHTER ⊘ ⊘ ⊘

My fantasy of Van Gogh painting in Provence with a portable French wooden easel like this one quickly turned into a more realistic call for a practical, portable cosmetic vanity. This easel cleverly holds a mirror, and instead of organizing a painter's palette, the drawer keeps shades of lipstick and eye shadows neatly arranged. Go au naturel and stay true to the wood finish or paint your easel a cool color like turquoise. When not in use, the easel folds up into its own carrying case for a Van Gogh vanity on the go!

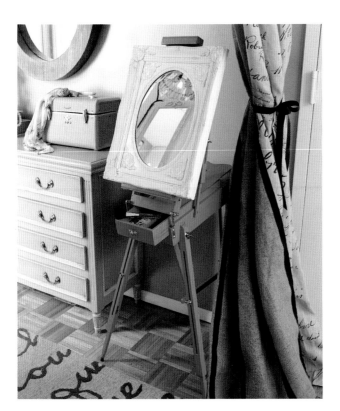

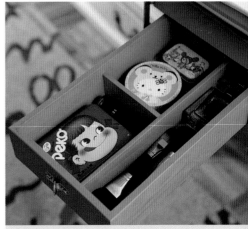

Look, there's more!

Japanese candy tins are a delightful way to keep cosmetics and hairpins organized and stylishly stashed away.

Industrious Double-Duty Clamps

RANKING: QUICKIE ⊘ ⊘ ⊘

Talk about a shelf with benefits! With a few industrial C-clamps (in vibrant orange), you can double the storage and style potential of a simple shelf. These C-clamps are strong enough to hold coats, bags, and umbrellas, but the best news is that they are removable—no nails or screws are necessary to shift these clamps into work mode. Go a little wild and choose lipstick red, blue, or yellow. When you move, just untwist and go.

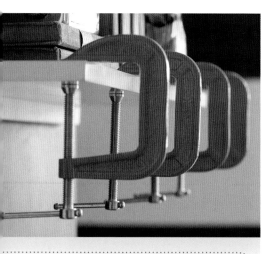

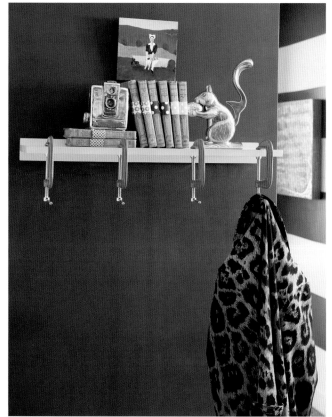

Look, there's more!

Mini felt upholstery pads placed on the inside tip of the C-clamp swivel screw and the opening of the orange frame protect a shelf from dents and scratches.

Open Book Chair

RANKING: QUICKIE ☺ ☺ ☺

"God Save the Queen" and this chair! Decoupaged with a British accent, this chair stalwartly guards piles of books from top to bottom. Chairs are a no-fuss destination for books that need a place to land. Just embrace the art of "stack and pile" to organize books by size or color.

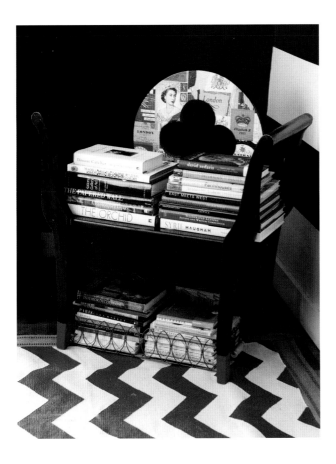

Look, there's more!

Bright British red paint gives these chair legs a quirky kick. Just giving the feet a splash of color makes it a standout.

In a Nutshell

Don't be afraid to store and display items you use every day out in the open. Books and coats are just two examples of objects that look chic in view, especially if hooks and shelving are stylish, too.

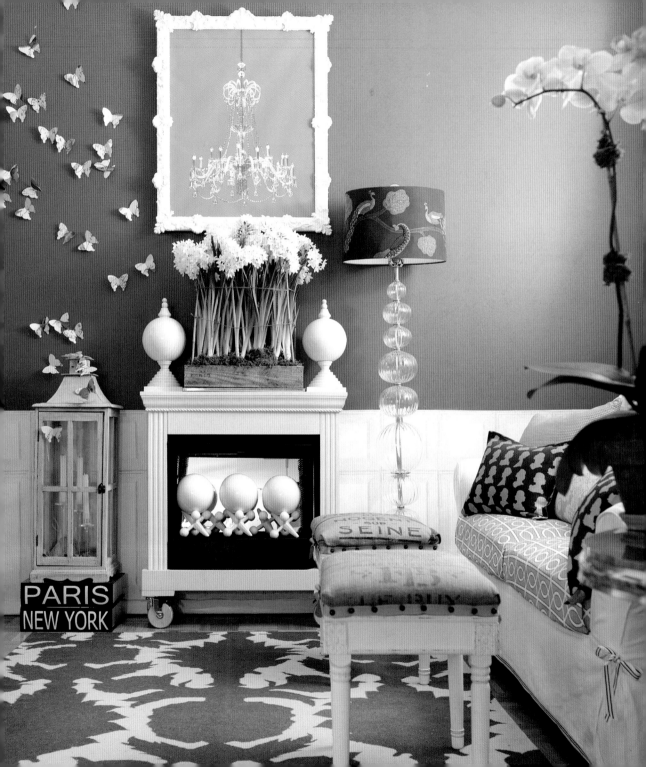

PARIS
NEW YORK

Faux Real

"Art is what you can get away with."
—Andy Warhol, *The Philosophy of Andy Warhol:*
 From A to B and Back Again, 1975

To live luxuriously and elegantly in a featureless box, you sometimes need a smoke-and-mirrors approach. It takes a stylish sleight of hand to feign the allure of the well-appointed home while keeping the money in your purse from doing a disappearing act. Call them fakes, stand-ins, or poseurs, a design list of high style wannabes make up my "faux-real" bag of tricks: faux fixes that are fast to do, playful with scale, and always lighthearted as they parody their more serious originals.

Adopting a faux-real mindset can make you fearless about your decorating choices. Instead of concentrating on what you can't do or can't have in a small space, faux-real thinking opens up the world of possibility. You'll capture the essence of the genuine articles in clever and unexpected ways. Warm fireplace? Rich paneled molding? Antique mirror? Stainless steel kitchen? No problem. Until you make it, fake it—and do it with a dose of gleeful irreverence!

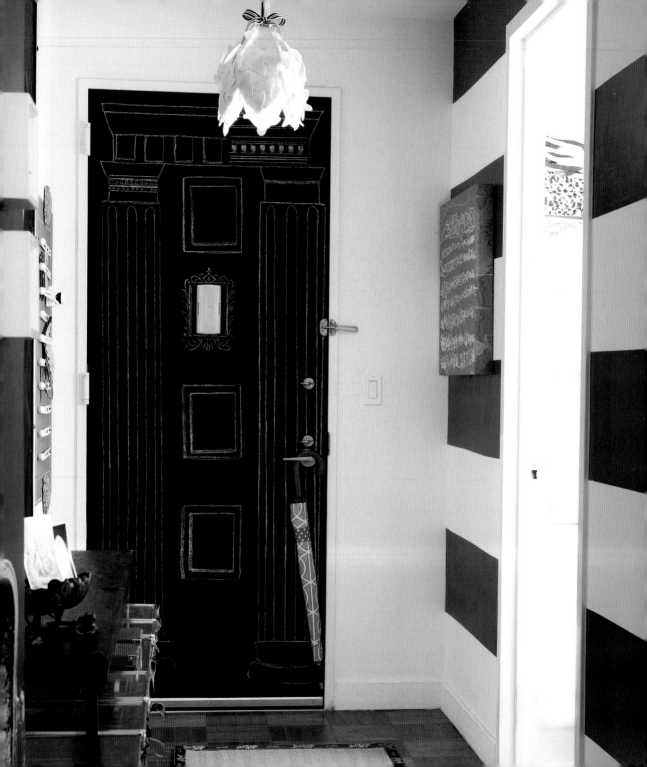

Classical Chalk Renderings

RANKING: QUICKIE ⏱ ⏱ ⏱

The slightest hint of solid wood paneling and architectural molding raises the style caliber of a room. This unassuming front door is painted with chalkboard paint and embellished with chalk drawings of make-believe cornices and roman columns—ambitious design dreams that give a run-of-the-mill foyer theatrical presence.

BEFORE

Look, there's more!

Polyurethane molding can be ordered in a 12-inch-long sample size for less than the cost of subway fare. Paint the molding strips with chalkboard paint and outline the raised edges with chalk to give your flat door a three-dimensional look. A magnetic strip glued to the back lets you attach molding strips to a metal front door.

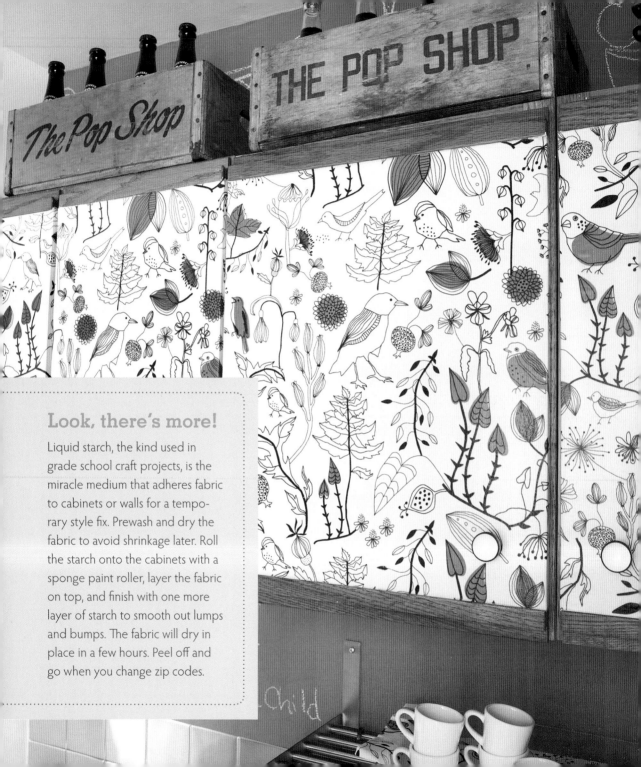

Look, there's more!

Liquid starch, the kind used in grade school craft projects, is the miracle medium that adheres fabric to cabinets or walls for a temporary style fix. Prewash and dry the fabric to avoid shrinkage later. Roll the starch onto the cabinets with a sponge paint roller, layer the fabric on top, and finish with one more layer of starch to smooth out lumps and bumps. The fabric will dry in place in a few hours. Peel off and go when you change zip codes.

Almost Custom-Made Cupboards

RANKING: WEEKENDER ☺ ☺ ☺

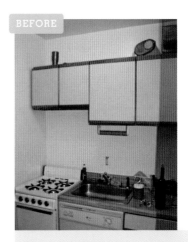

When they wrote the joke about a room being so small you have to step outside to change your mind, they were talking about your kitchen, right? It's hard to add more inches to a kitchen, but there's no need to be stuck with boring, generic cabinets. These fabric-covered cupboard doors look custom-made with the help of decoupage glue and a few yards of fabric. For a flawless result, light sanding and priming are a must before you decoupage.

In a Nutshell

Are you smarter (and more creative) than a third grader? With grade school craft supplies like chalk, paint, and glue, you'll become head of the class and graduate with new designer skills that let you create a luxe look as easy as 1-2-3.

Stenciled Paneling

RANKING: WEEKENDER ☺ ☺ ☺

This painted panel molding may be an imposter, but it's a brilliant alternative to the pricey wood original. You don't need to be an artist. With a stencil kit and a flat round brush in hand, you can replicate the richness and character of real wood molding on any wall. Use a dry-brush technique for stenciling success.

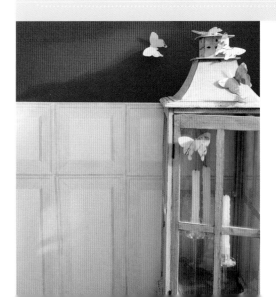

You've Been Framed Architecture

When the only architectural interest in your little nest is the molding on a picture frame, you've got the green light to go faux. Cover an entire wall with salvaged frames to project a much-needed architectural alias. Paint the frames the same color as the wall to mimic the texture and relief of real wood molding but use a high-gloss finish for a little shimmer. A black crow wall decal fills one frame, and a handful of vintage letterpress letters rests perfectly without glue or tape on an inside frame ledge. This sophisticated monochromatic theme speaks style volumes.

Look, there's more!

Happy accidents can become design opportunities. Add broken frames to your wall collage to artfully shift it off-kilter.

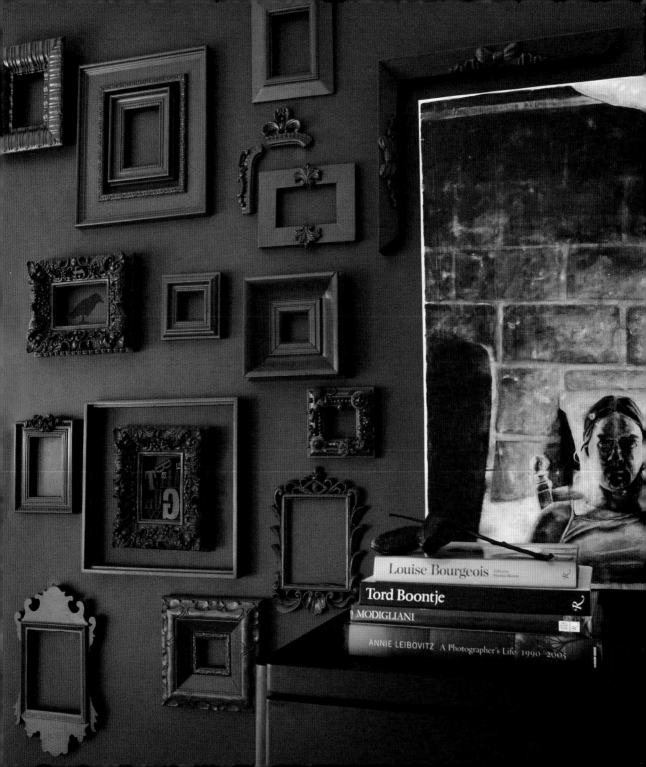

Louise Bourgeois

Tord Boontje

MODIGLIANI

ANNIE LEIBOVITZ A Photographer's Life 1990–2005

Who You Gonna Call?

Hardware stores will happily cut weather stripping to size for a small fee. Be sure to have exact measurements on hand for the lengths you need.

A-List Gallery Frames

RANKING: QUICKIE ⊘⊘⊘

Oversized frames can help you pull off that cool art gallery vibe, but when the frame cost is double the price of the art itself, it's time for a visit to your local hardware store—an untapped faux framing resource. Doorjamb weather stripping has a rubber side that keeps artwork safely in place and a metal side with predrilled holes that attach to the wall with decorative upholstery tacks.

Look, there's more!

Doorjamb weather stripping comes in a variety of colors and finishes to coordinate with your artwork. Go to town with white, galvanized metal, or gold.

Won't Commit Wallpaper

RANKING: QUICKIE ✓✓✓

Unleash your wallpaper. Sometimes you need only a little pattern or color to make a grand style gesture. If the idea of wallpaper installation sounds too daunting, costly, or permanent, hang a few loose sheets from metal bulldog clips and just let them drop. To keep the paper tucked in around high-traffic areas, wrap up the paper ends at different heights with ribbon, as you would a curtain panel, for a most stylish stand-in.

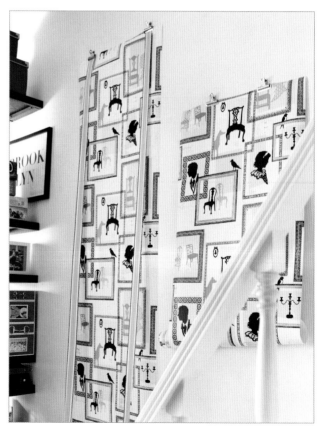

Art Mural Understudy

RANKING: WEEKENDER ⊘ ⊘ ⊘

You won't find any wire hangers in this closet! Thanks to this priceless publicity photo of Joan Crawford with her own shoe collection, these formerly dingy wardrobe closet doors are transformed into an art photography space. Think of removable wall murals as new art for your walls, entryway, and closet doors. A commercial digital printing service will enlarge your favorite photo onto adhesive vinyl that can be reused in your next space.

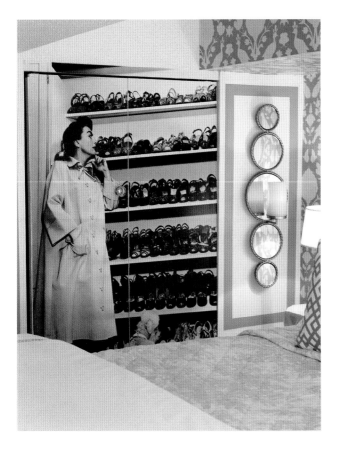

BEFORE

In a Nutshell

In a faux-real world, you can go big, even oversized, when it comes to art on the wall. The drama of large black-and-white images or loose designer wallpaper announces loud and clear that you don't subscribe to conventional wall applications.

Imitation Marble Panels

RANKING: ONE-NIGHTER ⊘ ⊘ ⊘

Genuine marble panels are out of reach for most decorating projects, but contact paper has come a long way with printed Carrara marble designs. Bordered by white picture frames mounted on plain white pantry doors, these marble panels look bona fide in small doses.

BEFORE

Mock Croc Tray

RANKING: QUICKIE ⊘ ⊘ ⊘

This embossed paper gives mock croc a good name! Lining an ordinary tray,
butler's table, or bookshelves with a touch of croc in glossy white, orange, red,
or navy gives a room that pampered look. This classic croc texture is more
than rich, it's exotic.

In a Nutshell

Rich, natural surfaces and textures
with a prestigious design history
carry their style cachet with them,
even in imitation form.

Fantasy Fireplace Façade

RANKING: ONE-NIGHTER ⊘ ⊘ ⊘

When you don't have a natural focal point in a room, a portable mantel or faux fireplace can squeeze into the tightest of spaces and feel as inviting as the real deal. Try lighting a faux fireplace with gel fuel canisters or a cluster of candles for an authentic glow.

Look, there's more!

Portable fireplaces get their get-up-and-go from large wooden casters that attach easily to the base. Now, fireplaces roll easily into the kitchen or bedroom— or wherever you need instant ambiance.

Lean a mirror against the inside back of the fireplace to magnify the glow of candlelight throughout your space.

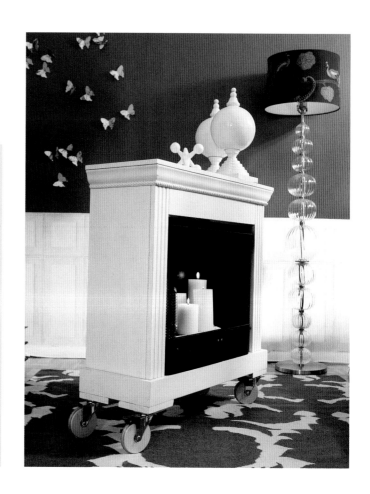

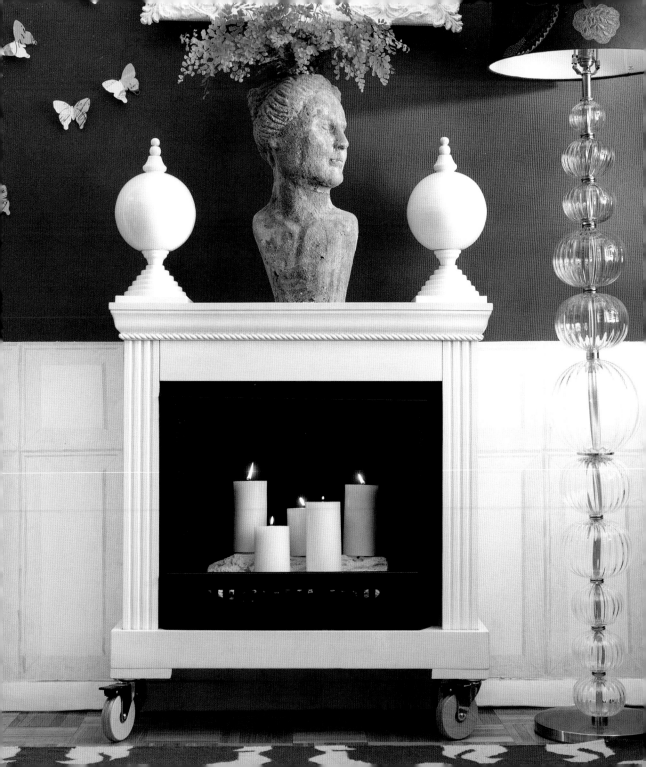

Larger than Life Andirons

RANKING: QUICKIE ⊙⊙⊙

The jig is up! This fireplace may just be a front, so pull off the ultimate style spoof and use decorative iron balls and jacks (in a jumbo cartoon size) as fabulous faux andirons. They're amusing and sculptural; painting them all-white gives them a modern edge.

In a Nutshell

A home without a hearth feels incomplete. An investment in a faux fireplace really pays off, but if you're going to fake it, go all the way with accessories that have a sense of humor and play with the scale of the authentic statement piece.

Make-Believe Louis XVI Chair

RANKING: ONE-NIGHTER ⊘ ⊘ ⊘

There's not a lot of room for extras in a tiny hallway, so carving out a little spot to sit down and put on your shoes without blocking traffic is a real extravagance. With a little trick of the eye, a Louis XVI–poseur chair printed on reusable vinyl adhesive dresses up this cramped corner without taking up any space. A DIY stool, painted to match, blends into the background and works as the ideal shoe stop.

In a Nutshell

The classic art of trompe l'oeil gets a fresh interpretation with new digital printing technology. Reproduction images are repositionable, reusable, and affordable and can fool even you into seeing what isn't there.

Fur-Free Taxidermy

RANKING: QUICKIE ⊙ ⊙ ⊙

You just might raise a little animal and design consciousness with these tongue-in-cheek wall-mounted felt and papier-mâché critters that put the fun in "faux" taxidermy. Die-cut felt butterflies make these creatures surprisingly kid-friendly with their woodsy charm.

Chip off the Old Faux Bois

RANKING: ONE-NIGHTER ⊙ ⊙ ⊙

From furniture to fabric, *faux bois* ("false wood" in French) takes the art of imitation to new heights. Rustic faux bois in a modern city dwelling strikes the perfect balance between cozy and kitsch. This DIY nightstand is made from papier-mâché and a cardboard tube made for pouring concrete. It's surprisingly lightweight and durable, would feel right at home in a child's room, and can double as a stool.

How Did You Do That?

1. Buy a 12-inch-diameter cardboard tube used to pour and mold concrete.
2. Cut the tube so that it stands 20 inches tall. Cut two pieces of scrap cardboard to fit the top and bottom of the tube. Use masking tape to keep them in place.
3. Cut and layer two to four oval pieces of cardboard on top of each other to resemble the knots in a wood log. Staple pieces to the tube in a random pattern.
4. Cut strips of Styrofoam pipe insulation to mimic ridges of bark on a log. Attach these strips with masking tape.
5. Mix modeling compound or instant papier-mâché with water according to the manufacturer's instructions. Cover the entire cardboard log, including the knots and ridges, with the mixture. Use a leveler to make sure the top and bottom surfaces are balanced and aligned. Allow 24 to 48 hours for the project to dry completely.
6. Smooth the surface of the log with a layer of finishing clay.
7. When it's completely dry, prime your faux bois log with white gesso and paint it a color of your choice.
8. For extra durability, seal with clear shellac or varnish.

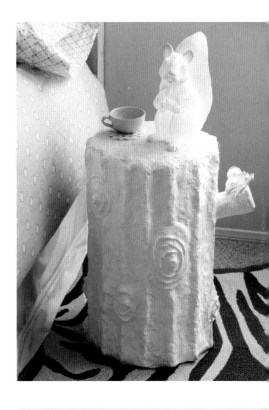

In a Nutshell

Exaggerated, cartoonlike, overscaled décor is so undeniably faux it lifts the interior mood of a home with pure joy.

Stainless Steel by Proxy

Stainless steel is the gold standard when it comes to dream kitchen finishes. If you don't want to splurge on steel now, go for a gleaming lookalike. Self-stick brushed aluminum tiles transformed this backsplash without messy glues, grout, or having to call in a tile guy. Aluminum tiles cut easily with regular scissors for a perfect fit anywhere, even in tight corners. Fickle homeowners or renters, relax. These tiles can be removed at any time without any wall damage.

In a Nutshell

Veneers that mimic the sheen and reflection of sophisticated designer surfaces bolster the luxury ranking of your special space.

Spitting Image Antique Mirror

RANKING: QUICKIE ⊙⊙⊙

They put a man on the moon—and then invented a spray that takes any plain glass surface and turns it into a reflective mirror. After four coats of the spray, this glass picture frame has a smoky antique mirror finish that looks like it's weathered wonderfully over time.

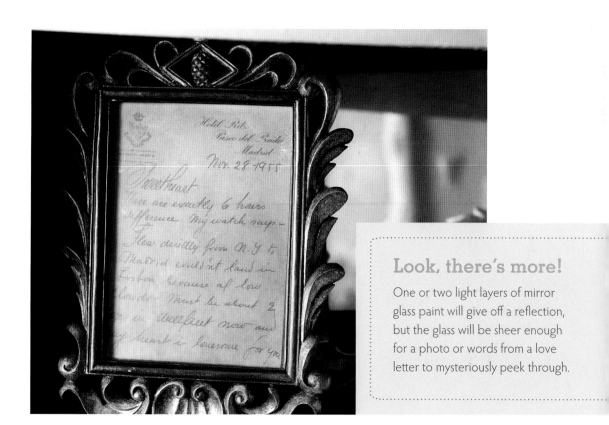

Look, there's more!

One or two light layers of mirror glass paint will give off a reflection, but the glass will be sheer enough for a photo or words from a love letter to mysteriously peek through.

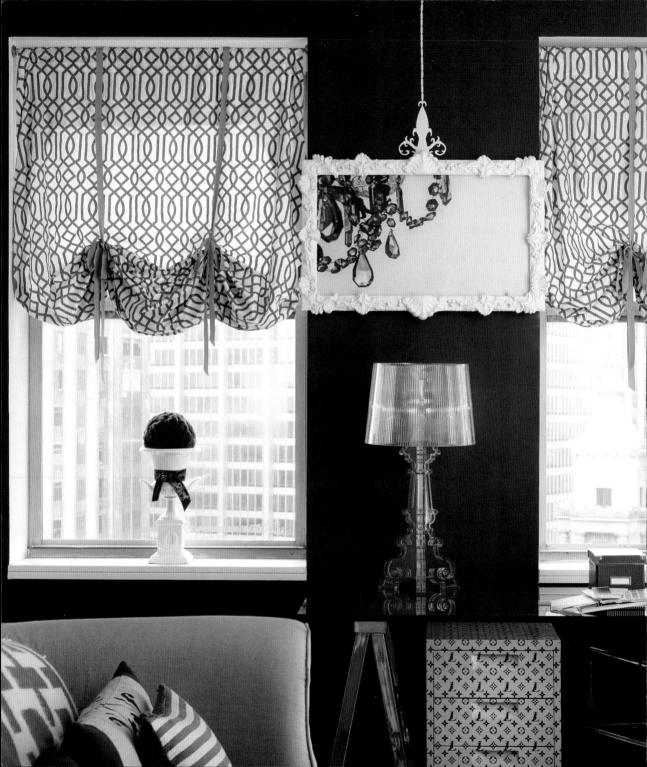

Fabricated Shades

RANKING: ONE-NIGHTER ⊘ ⊘ ⊘

When classic balloon shades show off this much style swagger, who would guess they are made from extra-long twin-size fitted sheets? The lower half of each sheet's elasticized edge is left intact to create the billowing effect. To restyle the upper half, insert a safety pin halfway up each side edge to secure the lower elastic. Pick out a few stitches above each pin to open the casing, then clip and remove the upper elastic. Transform the folded top edge into a no-sew rod pocket by opening up each top corner seam, slipping in the curtain rod, and fusing the fabric layers together with strips of iron-on fusible webbing. Finish with two grosgrain ribbons, pinned to the top of the shade so that they cascade down evenly on each side, almost to the sill. Tie the ribbon ends together at various heights to allow the shade to function up and down just like its authentic design inspiration.

Doppelgänger Double Curtain Rods

RANKING: QUICKIE ⊘⊘⊘

Think you're seeing double? These double-tension rods are the quick-
change artists of the décor world. Just pop them in without a care in the
world (or any holes in the wall) and dress your space with an opulence
that usually only an atelier can provide. Drape textured sheer fabrics
under heavier silks and watch your windows go from dull to deluxe. Metal
finishes like brushed nickel, bronze, and antique gold will say "designer"
before you get a chance to.

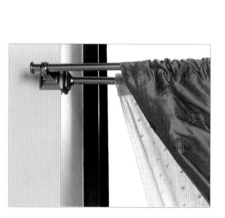

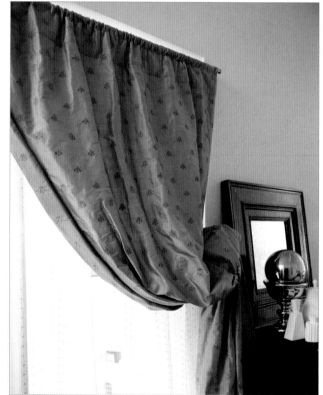

Add-on Sisal Rug Border

RANKING: QUICKIE ⊘⊘⊘

If your area rug falls a little short on square inches or on style, fake a custom
fit with upholstery jute webbing. Ordinary carpet tape keeps your add-on
border in place for a chic but cheap designer showroom upgrade. Different
color weaves keep your style options open.

In a Nutshell

Always dress to impress—and
that includes windows and floors!
Curtain panels will look
custom-tailored when paired
with polished modern hardware.

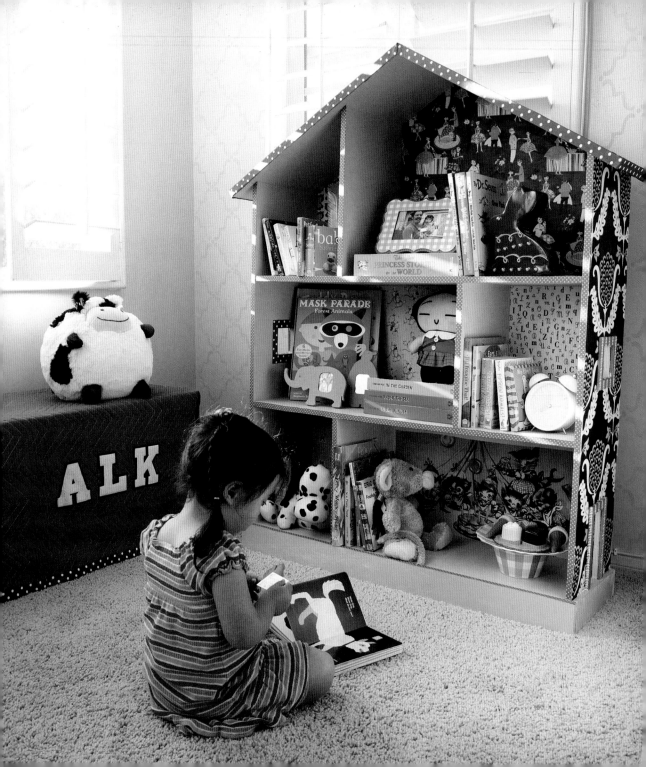

Pint-Sized Posh

"The most effective kind of education is that a child should play amongst lovely things."
—Plato, *The Laws*, 360 B.C.

If you're lucky enough to have a little peanut in your life to design for, then you know how much you want to indulge in every theme, design trend, and color of the rainbow. When I recently started to design my niece's room, I was thrilled to have the chance to create a fantasy world tied up in a pink bow. But then reality hit. I had to focus on a decorating approach that would have a long design life and help her tiny space double as a guest room for a large extended family.

Making children's rooms feel fresh and modern yet cozy is a balancing act. It's a playful pull between sophisticated fabrics with quirky patterns and chic accessories with whimsical details that appeal to a child's sense of fantasy. It's important to choose colors that are rich and inviting yet don't scream "theme park." Sprinkling in comforting touches of nostalgia will give a child's room warmth and longevity.

To keep posh tots living and playing happily in their nutshells, splurge on foundation pieces like headboards and dressers that are not too age-specific. Then make room for their personalities to shine through with colorful pillows, throws, and trendy lighting that they help choose—elements that can be changed out as quickly as they grow.

Tissue Pom-Pom Lampshade

RANKING: QUICKIE ⊘ ⊘ ⊘

They look fabulous at birthday parties and weddings, so why not use them for home décor? Tissue paper pom-poms resembling delicate peonies and dahlias appear light enough to float in the air. Hang them "invisibly" from a little girl's bedroom ceiling with nylon fishing line or use them to dress up a plain lampshade. To keep the look sophisticated but still sweet, choose a mature color palette of pale pinks and gray. Buy tissue pom-poms at party supply shops or make your own: Crease stacks of colored tissue paper into 1 ¼-inch accordion folds. Tie the middle of the stack with wire and use scissors to trim the edges to be rounded or pointed for different petal silhouettes. Open each fold of tissue to fluff out the petals before attaching the fishing line. The more blooms, the merrier. For extra safety around lamps, use a low-wattage CFL bulb and allow at least 3 inches of space between the paper and the lightbulb.

Look, there's more!

Enchanting paper flowers adorn the outside and underside of this extra-large hanging lampshade. A design mix of pom-poms and small Chinese paper lanterns is an affordable way to add lighting and texture to a lifeless corner. Just stay true to a sophisticated tone-on-tone color scheme so the look doesn't stray into birthday party décor territory.

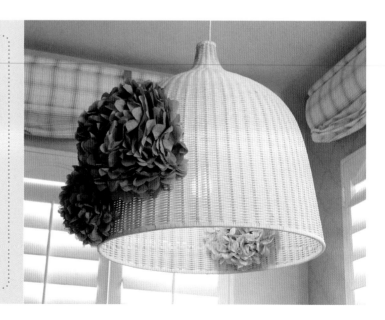

Flouncy Flowers Beanbag

RANKING: ONE-NIGHTER ⊙ ⊙ ⊙

The beanbag chair hasn't really changed its look since it popped onto the scene forty years ago—it's definitely time for a style intervention! Buy an inexpensive beanbag chair and embellish the removable cover with circles or flowers die-cut from colored felt. Cluster them in groups around the beanbag, then attach them with washable fabric glue. A dab of glue in the center of each felt piece allows the shapes to flounce around freely. No child will be able to resist lounging on this beanbag revival. Machine-wash the cover in cold water and dry on a cool setting.

In a Nutshell

Floral flourishes in a little girl's room are especially irresistible when displayed in clusters. Bundle up blooms in grown-up color combinations and use them to embellish unremarkable accessories like a lampshade.

Silhouette Cuckoo Clocks

RANKING: ONE-NIGHTER ⊘ ⊘ ⊘

A whimsical take on the traditional Swiss cuckoo clock, these decorative silhouette timepieces made for "show" won't keep time, but they do strike the right design chord with their woodsy personality. Once used as store displays, they now have a homemade touch with the addition of felted acorns, mushrooms, and fabric pinecones. A bit of our family's history is preserved in the wool-covered birds stitched from my father's tweed coat.

Look, there's more!

Here's an insider secret—props once used in retail store displays are often available for purchase, or better yet, are free for the asking. Inquire with the management and be prepared to wait until displays change for the season.

Blah, Blah, Blah Pillow

RANKING: QUICKIE ⊘⊘⊘

Message pillows with a grown-up attitude are the perfect blend of naughty and nice to give charm to a child's room. Iron-on black felt letters make it easy for children to say what's really on their minds. Use presewn pillow covers to make pillow messages in nothing flat.

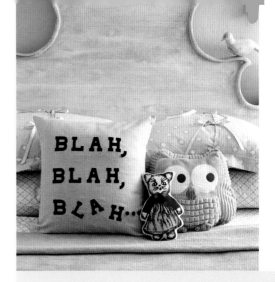

Just Press Play Kiddie Greetings

RANKING: QUICKIE ⊘⊘⊘

"Brush your teeth, sweetie!" Surprise a child with daily messages you put onto recordable sound chips (the kind found in talking stuffed animals and greeting cards). This squirrel's pocket is big enough to hold a few nuts or a sound chip that you can open any time to update your message. Attach a suction cup on the back so you can hang it on a bathroom or bedroom mirror.

In a Nutshell

Embrace the notion of "instant" messaging in a child's room with quick iron-on letters that allow you to customize and personalize pillows. And, with a push of a button, recordable sound chips, available at electronic stores, allow you to update fun messages and silly reminders.

MASK PARADE
Forest Animals

6
Fun Masks
and Mirrors
Inside!

Stephanie Trelogan

COME AND PLAY IN THE GARDEN

UNDER THE SEA

IN THE JUNGLE

The Best
PRINCESS STORIES
in the WORLD

The BIG
Green Eggs
and Ham

One Fish Two Fish Red Fish Blue Fish

Imagine That!

FIFTEEN ANIMALS

Itsy Weebsy Spider

Ita Potty Time

Welcome to the Dollhouse Bookshelf

RANKING: ONE-NIGHTER ☺ ☺ ☺

A child's love of reading is celebrated in style with a book nook decorated as a charming dollhouse. A patchwork of fabric layered in place with liquid starch adorns the bookcase walls and roof with the look of wallpaper that can be changed out as a child grows. Personalize the inside walls with photos and art to mix and match with books.

Look, there's more!

Polka dot fabric tape is a no-stress way to finish off the edge of a shelf without resorting to messy glue or paint.

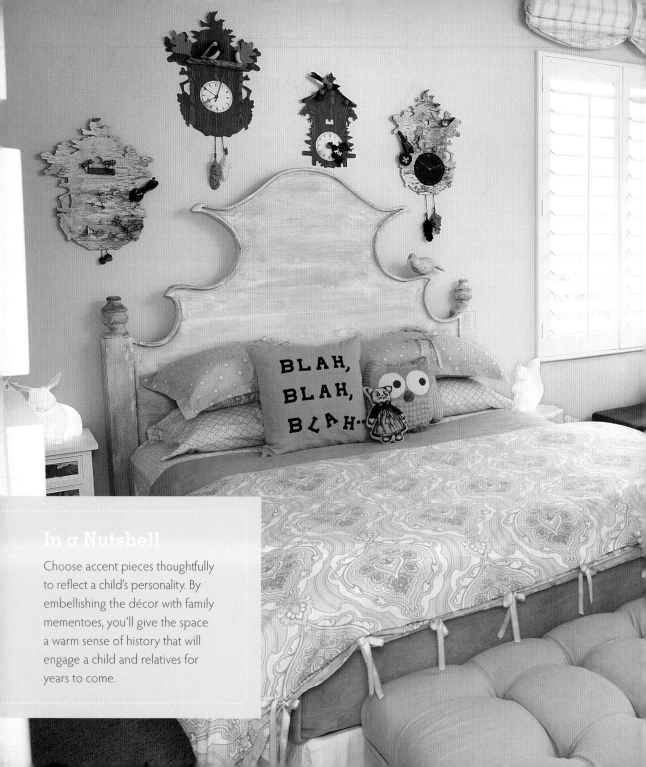

BLAH,
BLAH,
BLAH.

In a Nutshell

Choose accent pieces thoughtfully
to reflect a child's personality. By
embellishing the décor with family
mementoes, you'll give the space
a warm sense of history that will
engage a child and relatives for
years to come.

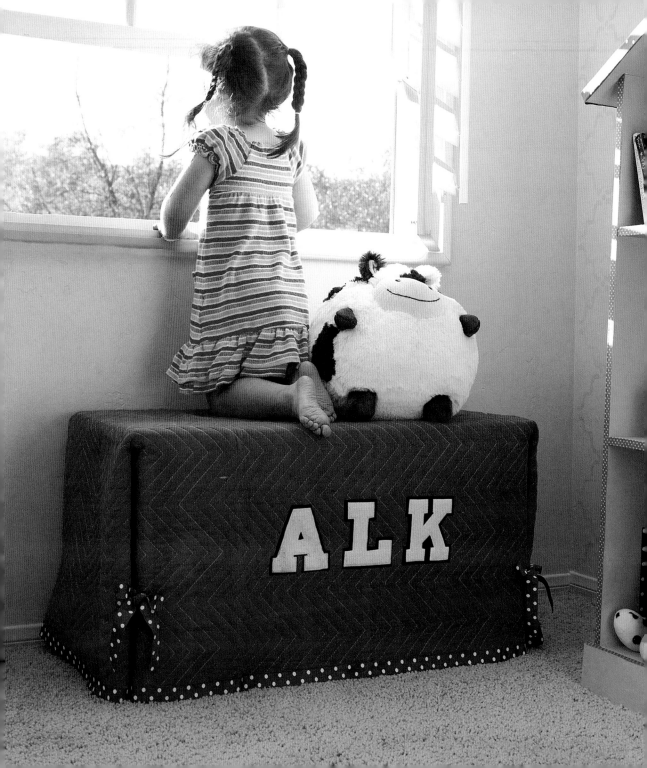

No-Sew Toy Box Slipcovers

RANKING: ONE-NIGHTER ⊘ ⊘ ⊘

Washable slipcovers and kids are a match made in heaven! Now keep messy toy boxes under wraps by converting professional mover's blankets into slipcovers. Measure the top and sides of the toy box for a custom fit and cut the blanket to size. Fold pleats at each corner and tie with ribbon you attach with glue. A softly padded blanket cover makes a toy box a great place to sit too.

How Did You Do That?

1. Use a tape measure to measure up one side of the toy box, across the top, and down the other side, starting and ending at the floor. Then do the same to measure up the back of the box, across the top, and down the front. Jot down your measurements; mine were 65 ½ by 49 inches.
2. Cut a rectangle from the mover's blanket to your dimensions.
3. Press wide ribbon in half lengthwise. Glue or fuse one half of the ribbon to the front of the slipcover and wrap the other half behind the blanket to finish the cut edges all around.
4. Drape the blanket over the toy box, centering it so all edges evenly touch the floor.
5. Tuck in the excess at each corner by making a neat pleat
6. Glue two pieces of matching ribbon to the blanket at each pleat. When the glue dries, tie the ribbon ends together in a bow to hold the pleat closed.

Who You Gonna Call?

They're still a tried-and-true stop for cardboard boxes and packing tape, but now moving supply companies also offer durable, affordable blankets in an array of bright colors. If you buy in bulk, many moving supply companies will imprint binding trims with your child's name or a logo.

Look, there's more!

Iron-on varsity letters put a personal and preppy stamp on blanket slipcovers.

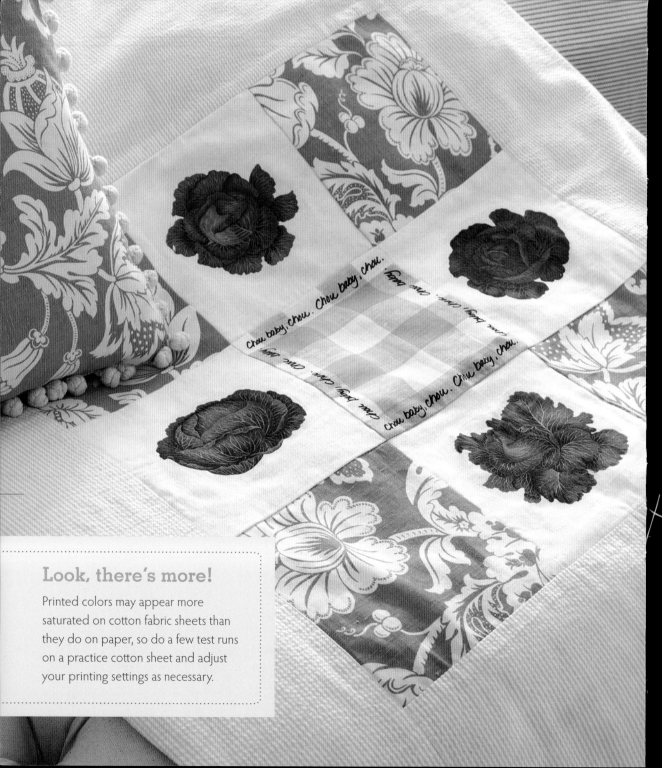

Look, there's more!

Printed colors may appear more saturated on cotton fabric sheets than they do on paper, so do a few test runs on a practice cotton sheet and adjust your printing settings as necessary.

Not Your Grandmother's Quilt

RANKING: ONE-NIGHTER ☺ ☺ ☺

Playing on the French term of endearment, *mon petit chou* ("my little cabbage"), this quilt looks and feels just as cozy and personal as the traditional hand-stitched patchwork that inspired it—without taking months to complete. By transferring your favorite images directly onto ink-jet printable photo fabric, you can customize a quilt for the tot in your life. Choose one graphic image as the base, introduce two contrasting patterns of fabric into the design, and incorporate some text or lettering. Your quilt will feel youthful, not old-fashioned.

How Did You Do That?

1. Using an ink-jet printer, print your favorite images directly onto cotton photo fabric sheets. Feed the standard 8 ½-by-11-inch sheets into the printer tray one at a time. Please note that instructions may vary according to the manufacturer.
2. Peel the paper backing from each printed fabric sheet. The printed fabric will feel soft and pliable, and the ink will be dry enough to work with.
3. Cut patches for the quilt from the printed fabric and other fabrics you have selected. Sew the patches together. The finished quilt will be washable in cold water after 24 hours. Dry on a cool setting.

Wild Animal Border

RANKING: QUICKIE ⊘⊘⊘

This printed zebra rug breaks out of its stripes-only style niche with a cool lavender border. To create the border, lay the rug over a large piece of lavender felt (sold by the yard in fabric stores) and secure invisibly with a few strips of double-sided carpet tape. Measure and mark 2 inches beyond the edge of the rug all around and cut the felt with scissors. The colored border visually expands the floor space, and the entire liner adds durability in a world of hard-playing rug rats. Animal prints are sophisticated décor neutrals. See for yourself how a colored border makes zebra stripes equally at home in a child's room as in a grown-up's lair.

Look, there's more!

Carpet tape keeps a felt liner perfectly in place even through heavy kid traffic. On hardwood floors, use a nonslip rubber pad under a felted rug to keep it safely in place.

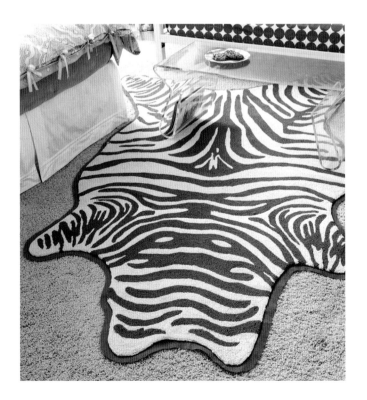

Bilingual Baby Mobile

RANKING: QUICKIE ⊘ ⊘ ⊘

Mass-market crib mobiles have a short décor shelf life. This modern interpretation of a photo wire mobile has design possibilities that will grow as a child does. Clipping on a handful of vintage French language flash cards creates a changing art display that educates *bébé* à la mode.

Chalkboard by the Yard

RANKING: QUICKIE ⊘ ⊘ ⊘

Make a child's space a doodling free-for-all! Encourage a budding Picasso with a vinyl chalkboard cloth that ingeniously keeps scribbles off furniture and walls—chalk drawings on this specially treated material wipe clean. As a bonus, the cloth is portable enough to roll up easily and can transform any corner into activity central.

In a Nutshell

Accessories that are portable expand the boundaries of a child's play zone and keep the fun flowing from room to room.

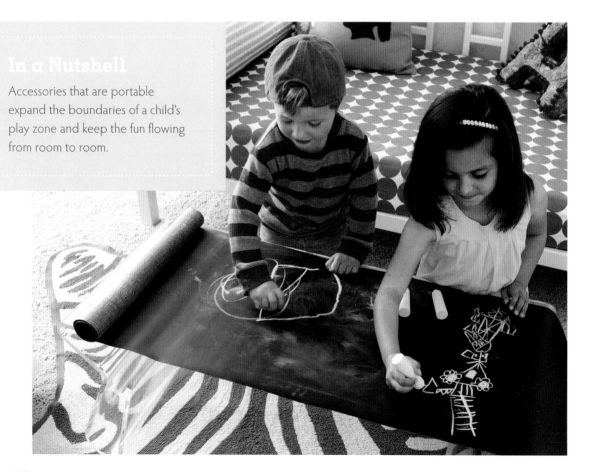

Top of the Chart Art

RANKING: QUICKIE ⊘ ⊘ ⊘

"Little Miss Muffet" might not be climbing the music charts anytime soon, but vintage children's records strike all the right design notes as cheerful art in a kid's room. Customize a collection of nostalgic records by framing them in a deep shadowboxes lined with novelty printed fabrics.

Look, there's more!

Many vintage children's records are the old 78-rpm stamped vinyl that measures between 10 and 12 inches in diameter—good information to keep in your pocket when you go frame shopping.

APPENDICES

Who You Gonna Call?

UNTAPPED DESIGN RESOURCES

Accessories

BAKING SUPPLIERS

Decorative cake boxes can be used to organize storage in a closet, while baker's twine can be used to attach tags and labels. Styrofoam cake dummy forms can serve as armatures for papier-mâché projects, and candy molds filled with sculpting clay instead of chocolate may be the start of one-of-a-kind décor projects.

CHEMISTRY SUPPLIERS

Suppliers of chemistry equipment offer glass flasks, test tubes, and beakers that look cool repurposed as vases or as containers that organize supplies on a vanity or in medicine chest.

CLIMBING AND HIKING SURPLUS

Suppliers of outdoor recreational equipment stock colorful bungee cords and rubber tubing that can be stretched across a wall for all kinds of instant storage.

DIGITAL PRINTING COMPANIES

From producing fabric transfers for pillows to printing Duratrans sheets for light boxes, a local printer can help you customize your designs for home décor projects.

NAUTICAL SUPPLIERS

Nautical suppliers offer authentic items such as rope ladders for accessorizing bunk beds and used porthole windows, which are easily adapted into mirrors. Standard nautical ring pulls make stylish and modern hardware for furniture or cabinets.

STORE DISPLAY CLOSEOUTS

Online outlets are great places to shop from a large supply of previously used shelving and display items. You may find inexpensive garment racks (which will look modern if you paint them in bright pop colors), three-way beveled wardrobe mirrors on wheels, Lucite shoe display boxes, and shelving that you can use to neatly organize accessories in a home closet.

UPHOLSTERY SUPPLIERS

Upholstery suppliers stock everything from decorative nail heads to inexpensive burlap and jute webbing for embellishing furniture, curtains, and rugs on a budget.

Engraving and Monogramming

SPORTS EMBROIDERY SHOPS

A great resource for authentic varsity-jacket lettering, these sewing specialists can embroider personal monograms on fleece blankets and pillows as well.

TROPHY ENGRAVERS

Trophy engravers don't limit their work to pricey glass and silver; they have the tools and expertise to engrave inexpensive plastic or Lucite trays and

picture frames provided by you for a sophisticated style upgrade.

Fabric and Furnishings

HOTEL FURNITURE WAREHOUSES

Hotel surplus warehouses are a vast resource for gently used armoires, mirrors of every style, coffee tables, chairs, lamps, and headboards. The prices are so low, you can afford to get pieces you find there professionally reupholstered or repainted.

MILITARY SURPLUS

Military surplus outlets stock Swiss, French, and Italian army wool blankets that can be used as ottoman, chair, or stool covers. You can also find lightweight parachute fabric to create an airy bed canopy.

MOVING SUPPLY COMPANIES

Moving supply houses sell durable quilted moving blankets in bright colors like blue, red, tan, and apple-green. The blankets are perfect for no-sew slipcovers for toy boxes and ottomans, and they can be decorated or monogrammed.

Painting and Murals

AUTO BODY PAINT SHOPS

Auto body paint shops specialize in high lacquer paint finishes that are ideal for revitalizing secondhand metal bookshelves and desks. Pick colors from the Mercedes-Benz or Porsche paint book and negotiate painting more than one piece at a time for the best rate.

BUS WRAP AD COMPANIES

The same thin adhesive sheets that are used to wrap public vehicles with vinyl ads can be custom-printed to decorate objects. The ad company will work with you to fine-tune and size your design for anything from file cabinets to closet doors.

Professional Services

DRY CLEANER

This local neighborhood resource can become your personal atelier for sewing pillows and curtain panels.

ELECTRICIAN

To convert light fixtures of any kind into portable plug-ins, a local electrician can be an invaluable resource.

HARDWARE STORE

Better hardware stores will make simple straight cuts in wood, metal, and weather stripping and will drill holes for a nominal fee.

LUMBERYARD

A lumberyard will make perfectly mitered cuts in wood and polyurethane molding strips for a professional look.

WALLPAPER PROFESSIONALS

They're not just for hanging wallpaper; call your local wallpaper hangers to remove messy stucco from walls and ceilings.

Living in a Nutshell Survival Kit

CHALK INK PENS

Chalk ink pens write like a paint pen, but the ink dries like chalk. They are perfect for writing messages or menus on mirrors and other glass surfaces and erase with a damp cloth.

DECOUPAGE MEDIUM

Mod Podge is a glue and sealer all in one that dries clear and is nontoxic. Attach artwork to a plain tray or box with layers of Mod Podge medium for a decoupage finish.

FABRIC GLUE

MagnaTac is a permanent glue that dries clear and is washable on all fabrics, including silk and leather.

FABRIC TRANSFER T-SHIRT PAPER

Personalize everything with this inexpensive ink-jet–printable iron-on transfer paper. Artwork transfers permanently onto silk shantung and cotton.

GLUE GUN

For a quick, strong bond on plastic, glass, metal, or wood, hot-glue guns are essential. Choose a glue gun with a dual temperature setting and use a high- or low-temperature glue stick accordingly, depending on the materials you are bonding together. Glues that are melted at higher temperatures may burn certain fabrics and plastics. Use glue guns to attach trim to a slipcover or molding to a wooden picture frame.

GROMMET KIT

Metal rings or eyelets called grommets reinforce holes in fabric and are a no-sew option when making curtain panels or shower curtains. Install grommets using a hammer and a simple grommet kit, available at most hardware stores.

HAND-CRANKED CRAFT DRILL

A hand-cranked drill makes it easy to bore holes in wood, plastic, and soft metals without power cords or batteries. You can use it to drill holes to install decorative hardware, lighting, and more. The drill bits change out quickly. Fiskars makes a craft-friendly version.

HANDHELD STEAMER

For the same price as an iron, a small portable steamer allows you to smooth out wrinkles in bedding, curtains, and upholstery without having to remove them from beds or curtain rods.

INK-JET PRINTABLE PHOTO FABRIC

Printable 8 ½-by-11-inch cotton fabric sheets fit into any ink-jet printer paper tray. Print images or text directly onto the fabric without having to transfer images with an iron. Use printed fabric in projects like quilts, pillows, and tote bags.

LEVEL RULER

A combination straight level and measuring stick is key to installing a shelf or picture frame so that it hangs straight.

MR. CLEAN MAGIC ERASER

The Mr. Clean Magic Eraser is a special cleaning sponge that with just a little water effortlessly wipes off dirt and scuff marks from walls so they look bright and new again.

MUSEUM GEL OR PUTTY

Museum gel is clear and keeps glass or crystal objects invisibly secure on a table; it can also be used to help steady a stackable display. The putty is best on porcelain and ceramics. Both products are removable, reusable, and won't leave behind any marks or adhesive.

NO-SEW FUSIBLE WEBBING TAPE

Placed between two pieces of fabric, webbing tape fuses two layers of fabric together when exposed to the heat of an iron. It is useful for making permanent, washable, no-sew hems on curtains and other fabric projects.

PAINT CAN OPENER

This tool is usually free for the asking from local paint stores. Keep several of these metal openers on hand instead of ruining screwdrivers and butter knives.

PAINT PENS

These smooth-flowing markers filled with opaque paint permanently decorate glass, ceramic, wood, or metal. They are available in every color of the rainbow as well as metallics. Use them to add a piping trim to furniture or picture frames.

PAPER CUTTERS (STRAIGHT AND CIRCULAR)

Cutting the perfect straight edge is invaluable when printing out and trimming photos, cutting mats, or making place mats. Circular paper cutters make perfect doilies and decorative liners for trays and tabletops.

PHOTO PAPER

Keep photo paper on hand in both matte and glossy finishes to create instant artwork from personal photos.

PICTURE-HANGING KITS

Hang and swap out picture frames easily from wall to wall with picture-hanging hooks and nails that leave the tiniest holes and are easy to install.

REMOVABLE-ADHESIVE MOUNTING STRIPS, HOOKS, AND PICTURE HANGERS

Removable adhesive products let you hang posters and artwork on walls without hurting paint and finishes. Just pull a tab to remove.

REPOSITIONABLE GLUE DOTS

Mess-free repositionable dots adhere to paper, glass, plastic, and metal.

REPOSITIONABLE SPRAY MOUNT

Spray mount is used to adhere lightweight materials like paper, fabric, and plastic, yet allows work to be lifted and repositioned. It keeps stencils in place when painting and temporarily holds wallpaper on backs of bookshelves.

SANDPAPER SPONGE

Easier to handle than sandpaper sheets, sandpaper sponges allow you to smooth hard-to-reach crevices. They are perfect for wet sanding.

SPACKLE

Patch-N-Paint lightweight spackling compound is quick-drying and easy to sand.

SPRAY LUBRICANT

The versatile spray lubricant WD-40 removes squeaks in doors, makes windows easier to open, and even removes rust.

STUD FINDER

This handheld device determines the location of wood and metal framing studs in the wall. It's helpful when hanging lightweight shelves with wall anchors that must avoid hitting studs. This device will save you from punching too many unnecessary test holes in the wall.

T-PINS

Named for the T-shaped head, these pins securely anchor fabric in place. Use T-pins to keep slipcovers in place.

UPHOLSTERY TACKS

These decorative tacks have larger heads than regular tacks and are available in nickel or brass finishes. Place them close together along the edge of an ottoman or chair for a designer-upholstered look.

VELCRO HOOK-AND-LOOP FASTENERS

Iron-on fusible and adhesive Velcro fasteners work as no-sew closures on pillows, slipcovers, or table skirts.

WHITE CHALK

Regular chalkboard chalk lightly marks walls and fabric. When chalk marks are no longer needed, they can be removed with a soft cloth or a soft-bristle brush without leaving a trace. Keep chalk sharpened with a regular pencil sharpener.

Some Metric Conversions

INCHES	CENTIMETERS	FEET	METERS
2	5.1	1	0.3
4	10.2	2	0.6
6	15.2	3	0.9
8	20.3	4	1.2
10	25.4	5	1.5
15	38.1	6	1.8
20	50.8	7	2.1
25	63.5	8	2.4
30	76.2	9	2.7
35	88.9	10	3.0
40	101.6	11	3.3
45	114.3	12	3.6
50	127.0	13	4.0
55	139.7	14	4.3
60	152.4	15	4.6

I Want That!

Chapter One

PAGE 14
Poolside Blue paint color: benjaminmoore.com
Turquoise trellis pillows: milkandcookies@etsy.com

PAGE 17
Schumacher Chenonceau wallpaper in Fawn:
 sherwin-williams.com

PAGES 18–19
Camden tufted headboard: ballarddesigns.com
Matine toile quilt: potterybarn.com.
Pearl embroidered duvet cover: potterybarn.com

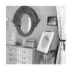

PAGE 22
French five-drawer chest: wisteria.com
Mansard mirror: restorationhardware.com

PAGE 23
Adorations curtain: anthropologie.com
Le Poème rug: ballarddesigns.com
Sanctuary paint color: benjaminmoore.com

PAGE 24
Verdant Green paint color: sherwin-williams.com

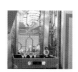

PAGE 27
Battery-operated picture light:
 improvementscatalog.com
Butler's tray table: zgallerie.com
Crystal chandelier pendant: gallery802.com
Montego mirror: ballarddesigns.com
Wall sconce: target.com (available online only)

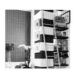

PAGE 28
Inreda ladder: ikea.com

PAGE 30

Wrought Iron paint color: benjaminmoore.com

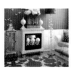

PAGE 36

Pink Corsage paint color: benjaminmoore.com
Thomas Paul green flock dhurrie rug:
 allmodern.com

PAGE 36

Yellow Moroccan bubble decal:
 byrdie graphics@etsy.com

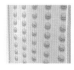

PAGE 38

Glue dots: createforless.com
Vintage milk bottle caps: etsy.com

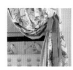

PAGE 39

Cecilia pink fabric: ikea.com

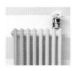

PAGE 40

Yellow, Bright Yellow, Banana Yellow,
Sundance, and Light Yellow paint colors:
 benjaminmoore.com

PAGE 41

Garden bust: wisteria.com

PAGE 41

Battery-operated spotlights: save-on-crafts.com

PAGE 42

Dog night-light: target.com

PAGE 44

Dupioni silk curtain: potterybarn.com

PAGE 45

Coretto tension rod: umbra.com

Chapter Two

PAGE 48

Rubber stamps and ink: theinkpadnyc.com

White-stitch border brown grosgrain ribbon:
daytonatrim.com

PAGE 50

Carey Lind pure geometric wallpaper:
sherwin-williams.com

I Heart Birkin tote bag: Avril Loreti@etsy.com

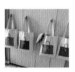

PAGE 50

Mother-of-pearl knob: anthropologie.com

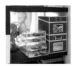

PAGE 51

Acrylic case 2-drawers (2 sets used for project):
muji.us.com

Fiskars hand drill: dickblick.com

Mini horse bits: horsetacksupply.com

PAGE 53

Custom vinyl wrap adhesive: graphitek.com

PAGE 56

Caviar tins: markys.com

PAGE 58

Temporary Chanel tattoos: chanel.com

Temporary ink-jet tattoo paper:
coastalbusiness.com

PAGE 60

Lou Lou chair: hivemodern.com

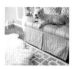

PAGE 61

Chip off the Block beige rug: poshtots.com

Shearling rug: ikea.com

PAGE 62

Lack bookshelf: ikea.com

Michael Miller Charlotte Rose cotton: fabric.com

Nickel bun feet: ferroushardware.com

Pantone metal storage boxes: dickblick.com

Upholstery foam (custom cut): diyupholstery.com

PAGE 63

Wood magazine holders: ikea.com

PAGES 64–65

Papier-mâché: dickblick.com

Paperclay: dickblick.com

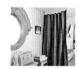

PAGE 66

Dignitet curtain wire: ikea.com

Stitch Witchery fusible webbing: joann.com

PAGE 67

Burlap: fabric.com

PAGE 68

Dwell Studio chinoiserie place mats:
 unicahome.com

PAGE 69

Paisley comforter set: overstock.com

Chapter Three

PAGE 73

Vintage magnifying lenses:
 eBay.com, etsy.com

PAGE 74

Chalk ink pens:
 chalkinkworldstore.com

PAGE 76

Rubber stamps: paper-source.com
Sealing wax: katespaperie.com

PAGE 77

Cursive knobs: anthropologie.com
Hayworth lingerie chest: pier1.com

PAGES 78–79

Fiber Etch: dharmatrading.com

PAGE 80

Rubber stamps: paper-source.com

PAGE 84

Until Dawn curtain: velocityartanddesign.com

PAGE 85

Cavallini pink bird paper: paper-source.com

PAGE 87

Custom static window film: graphitek.com
Waverly azalea window fabric: fabric.com

PAGE 88
Quilt: spiegel.com
Elephant stool: spiegel.com

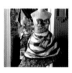

PAGE 89
Used dress forms and mannequins:
davessurplus.com

Chapter Four

PAGE 92
Bird glass cloche: shopterrain.com
Plastic nuts: auntbubbiesfakefood.com
Vintage porcelain nuts: etsy.com, flea markets

PAGE 94
Vintage trophies: eBay.com, etsy.com

PAGE 95
Cavallini Paris rubber stamps: paper-source.com
Manila tags: staples.com
Vintage egg basket: eBay.com

PAGE 96
Keep Calm and Carry On wall decal:
chuckEByrdWallart@etsy.com
Vintage first aid tin: eBay.com

PAGE 97
Vintage scout tins: eBay.com

PAGE 97
Small oval mirror: createforless.com

PAGES 98–99
Vintage Paint by Number canvases:
 eBay.com, etsy.com

PAGE 99
Hippity-Hop bunny lamp: anthropologie.com

PAGE 100
Decorative upholstery tacks:
 diyupholstery.com
Vintage grain sacks: eBay.com
Green grosgrain ribbon:
 So-Good Inc., New York, NY

PAGE 102
Vintage Italian military blankets:
 pinecreekoutdoors.com

PAGE 103
Peekaboo clear console table: cb2.com
Vintage blueprints: eBay.com

Chapter Five

PAGE 106
Duratrans light box print: endofgraphics.com

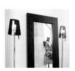

PAGE 108
Lamp wall decal: vinyldesign.com.au
Maglite D-cell mounting brackets:
 acehardware.com
White lamp cord: paperlanternstore.com

PAGE 109
Lightbulb decal: tastysuite.com

PAGE 110
Pendant cords: westelm.com

PAGE 111
Crystal pendant chandelier: gallery802.com

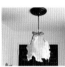

PAGE 112
Pendant light adaptor: ballarddesigns.com

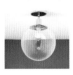

PAGE 113
Soft pink lightbulbs: lampsplus.com

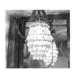

PAGE 114
Filament bulb: westelm.com

PAGE 115
Flameless candles:
 flamelesscandles.net

PAGE 115
Birch bark sheets: barkcanoe.com

PAGE 116
Katell bougie lamp:
 whotelsthestore.com
Mason glass desk: wshome.com

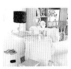

PAGE 117
Clear console: cb2.com

Chapter Six

PAGE 131

Tulipiere: thepinktrumpet.com

PAGE 131

Alphabet brads: shop.hobbylobby.com

Vintage train cases: etsy.com

PAGE 132

Striped silk taffeta fabric: moodfabrics.com

PAGES 132–33

Metal brads: 123stitch.com

Yellow key tags: staples.com

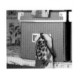

PAGE 134

Avery adhesive printable sheets: staples.com

Green Kassett boxes: ikea.com

PAGE 135

Portable sketchbook easel: eBay.com

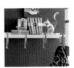

PAGE 136

Pony adjustable C-clamps: acehardware.com

Chapter Seven

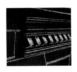

PAGE 141

Polyurethane molding samples:
 crown-molding.com

PAGE 142

Decoupage medium: michaels.com

Green Cecilia fabric: ikea.com

Sta Flo liquid starch: walmart.com

PAGE 143

Door panel stencil: designstencils.com

PAGE 144

Bee appliqués: decoratorssupply.com

Yellow ikat pendant lamp:

 Studio Jota@etsy.com

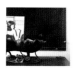

PAGE 147

Weather stripping: homedepot.com,

 better hardware stores

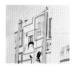

PAGE 148

Cameo wallpaper: anthropologie.com

Large bulldog clips: dickblick.com,

 staples.com

Yellow ribbon: So-Good Inc., New York, NY

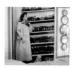

PAGE 149

Custom mural decal: graphitek.com

PAGE 150

Carrara marble contact paper: designyourwall.com

PAGE 151

Faux crocodile paper: katespaperie.com

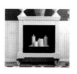

PAGES 152–53

Faux fireplace mantel: overstock.com

PAGES 152–53

Wooden caster wheels: coolcasters.com

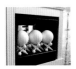

PAGE 154

Jumbo iron jacks: horseshoehardware.com

6-inch color balls: cb2.com

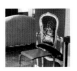

PAGE 155

Custom chair wall decal: graphitek.com

Hugo stool: ikea.com

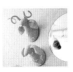

PAGE 156

Felt menagerie animal head: popdeluxe.net

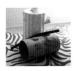

PAGE 157

Concrete form tube: homedepot.com

PAGE 157

Porcelain squirrel lamp: popdeluxe.net

PAGE 158

Metal kitchen wall tiles: improvementscatalog.com

PAGE 159

Krylon Looking Glass mirror spray: misterart.com

PAGES 160–61

Extra-long twin sheets: homegoods.com

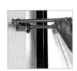

PAGE 162

Umbra double-tension rod: bedbathstore.com

PAGE 163

Pink Zig Zag Jaipuri rug: calypsostbarth.com

Red and black jute webbing:

 onlinefabricstore.net

Chapter Eight

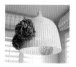

PAGE 166

Fiesta pom-poms: etsy.com

Leran pendant lamp: ikea.com

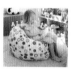

PAGE 167

Custom die-cut felt: kutz@etsy.com

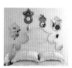

PAGE 168

Craft birds: michaels.com

Felt mushrooms, acorns, and pinecones: etsy.com

PAGE 169

Iron-on felt letters: createforless.com

PAGE 169

Recordable sound chips: amazon.com

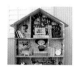

PAGE 170

Dollhouse fabric: trendyfabrics.com,
hancockfabrics.com, fabric.com

PAGES 170–71

Fabric tape: tayloredexpressions.com

PAGE 174

Iron-on chenille varsity letters: simplicity.com

Mover's blanket: moverssupplies.com

PAGES 176–77

Ink-jet printer fabric: softexpressions.com

PAGE 178

Faux zebra print rug: rugstudio.com

Wide lavender felt: onlinefabricstore.net

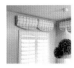

PAGE 179

Deco Wrap no-sew foam cornice: qvc.com

PAGE 180

Vintage toppers: eBay.com, etsy.com

PAGE 181

Umbra Petal photo holder:

 bedbathandbeyond.com

PAGE 182

Chalkboard cloth: onlinefabricstore.net

PAGE 183

Vintage records: eBay.com
White shadow box frames: target.com

Acknowledgments

There would be no *Living in a Nutshell* without unique spaces to decorate. My heartfelt thanks go to Beth King, who took a leap of faith, handed over her apartment keys, and gave me decorating carte blanche. And to Lee O'Connor who didn't wait a beat to say, "Yes, come on over!"

Much gratitude goes to Marta Hallett, who walked into my petite abode and immediately said, "This is a book," changing the trajectory of my publishing life. Many thanks, too, to my dear friend Marianne Irmler—ever magnanimous with her time, creative inspiration, and unyielding faith—who worked by my side to make every project come alive.

I am thankful for the fateful day when I met Audra Boltion, who enthusiastically introduced me to her world of publishing friends.

And I'm grateful to the kindness of friends and family who applauded the idea of my trading in my day job for the world of ribbons, paint, and glue guns: Joseph Lecz, Cyd Upson, Marlene Lee, Thomas Lee, Michael Newborn, Linda Stehno, and Jacques Kirch. A special *obrigada* to Paulo Carneiro, whose generosity of spirit I will never forget.

Many thanks to my photographer, Aimée Herring, who captured my slightly left of center design sensibility one fabulous frame at a time.

No one has been my cheerleader and champion longer and with more love than Donna Lee Kirch. I share this personal triumph with her and my little niece, Ava.

Finally, for her discerning creative vision and encouragement and for boldly taking a chance on a first-timer, I thank my editor, Elizabeth Viscott Sullivan, who, along with the unflagging support of Candie Frankel, transformed a book of my dreams into reality.

Photography Credits

All photography unless otherwise noted: Aimée Herring, © Janet Lee.

Front cover, pages 25 and 125: photography by Ryan Benyi.

Pages 18, 115, and 149: image of Joan Crawford: Hulton Archive/Getty Images.

Page 119, bottom: Aaron Wilcox Photography.

About the Author

Janet Lee is an Emmy Award-winning television show producer, styling and producing for leading home decorators, entrepreneurs, and designers such as Martha Stewart, B. Smith, and Thom Filicia. During her ten years as a senior producer for *The Oprah Show*, she worked closely with style greats like Nate Berkus. She has also been a home décor producer for Lifetime Television's *Our Home* and was featured on camera as their weekend decorator, demonstrating chic, easy DIY projects. She has also appeared on CBS's *The Early Show*, where she demonstrated her noncommittal, high-end-for-less décor ideas. Now a freelance producer, she lives in New York City.

www.livinginanutshell.com